PHOTOGRAPHY REMEMBERED

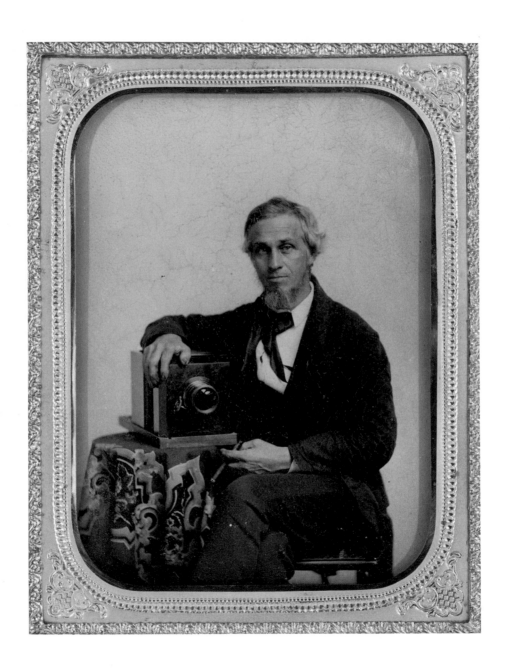

PHOTOGRAPHY REMEMBERED

A SELECTIVE VIEW FROM THE ROBERT W. LISLE COLLECTION

Visual Studies Workshop
Research Center
Rochester, N.Y.

November 1990
Gift of the museum

Frontispiece: *The Daguerreian Artist,* ambrotype, ca. 1855.
 This photographer is seated beside a half-plate Lewis-style daguerreian
 camera.

Inside Covers: Frank Chadwick(?), *Self-Portrait,* 1898. Front, negative; back, positive.
 The photographer stands with his view camera set and his hand ready to
 squeeze the shutter bulb at just the right moment.

Design: Germaine Clair Designs
 Norfolk, Virginia

Typesetting: B. F. Martin, Inc.

Printing: Teagle and Little, Inc.

ISBN: 0-940744-61-9

Library of Congress Catalog Number: 90-084178

© 1990 The Chrysler Museum, Olney Road and Mowbray Arch, Norfolk, Virginia
All rights reserved

Printed in the United States of America

To the creative
and spirited vision
of the pioneer photographer
and the camera's magical ability
to record it.

FOREWORD

It is with great pleasure that The Chrysler Museum presents this catalogue and concurrent exhibition of the Robert Lisle Collection. The opportunity to exhibit such a collection allows this institution to enlighten and entertain, and to do it in grand style. Photography has become such a vital part of our culture that it is hard to imagine our daily lives without its influence. This comprehensive collection gives insight into the invention, propagation and subsequent popularization of the medium which today has such profound influence on our lives. We are very grateful to Dr. Robert W. Lisle for his willingness to lend his collection for this exhibition. Sometimes whimsical, always pragmatic, the collection that Dr. Lisle has so lovingly assembled over the past two decades, along with the text he wrote for the catalogue, tells the story of photography. For his patience, insight, generosity and above all his friendship, we are truly appreciative.

Many thanks to The Chrysler Museum staff who always perform so wonderfully in preparing every exhibition. Assistant to the Curator of Photography Ronald L. Crusan has worked on every aspect of this exhibition. He did the bulk of the research, catalogued the objects, coordinated the photography, managed the exhibition display and assisted with the catalogue. His enthusiasm and intellectual prowess have been especially welcome on this complex exhibition. Curatorial Assistant Georgia Lasko has, as always, worked in good humor on many different tasks especially in typing the original material. Museum Photographer Scott Wolff has, in his usual perfectionist style, made wonderful photographs for this catalogue. Catherine Jordan, registrar, and Irene Roughton, associate registrar, have in their calculating methodology ensured that all objects are present and accounted for. Thanks also to Pat Sisk, slide librarian and maker of the exhibition labels.

For their encouragement and support throughout this project, thanks to Museum Director Robert Frankel and Deputy Director Roger Clisby. Also thanks to the Assistant to the Director, Shirley W. Beafore, who coordinated the reception for the exhibition.

Thanks to Willis Potter, chief preparator, who along with Susan Christian, Bernie Jacobs, Richard Hovorka and Carol Cody mounted the exhibition so splendidly. A hearty thanks to Jim Armbruster, shop foreman, and his crew Stephen Leickert, Stewart Howard, Sergio Escalante and Glen Miller for the preparation of the galleries. Librarians Rena Hudgins, Lynda Wright, Amy Masciola, Charlotte Frazier and Rosemary Dumais aided immensely in the research phase of the exhibition. For spreading the news of the exhibition far and wide thanks to our public relations and development staff, Robin Wedewer, Deanna Keim, Peggy Ryan, Molly McCarthy and last, but by no means least, Debbie Klimcyznski.

Brooks Johnson
Curator of Photography

PREFACE

Ever since photography's dramatic public debut in 1839, on a hot August afternoon in Paris, humankind's image of ourselves and our world has never been the same. This book and the concurrent exhibit affectionately salute the birth and vibrant youth of this magical medium of visual expression, which has reflected and perhaps at times even shaped the course of human history for over a century and a half.

The items presented, like characters in a play, were gleefully gathered and fondly organized over the past 20 years for the purpose of creating an historical, technical and aesthetic portrait of the early years of photography.

My desire to engage in such a pleasure hunt grew out of an initial romance with the art of making photographs – it being through the lens of a camera some 25 years ago that a more visually exciting and aesthetically more meaningful world came into personal focus. Almost coincidentally, there emerged an equally enthusiastic interest in the history of photography along with which came the curiously spontaneous desire to collect what I considered to be significant bits of photographic antiquity.

From a stumbling beginning, marked by the purchase of a $3 Brownie Box Camera, evolved the spirited pursuit of photographic gems that would tell the story of photography. With boundless Christmas Eve anticipation, I spent my free time, harpoon in hand, in search of whatever elusive photographic white whales might cross my bow.

With limited resources, over the course of two decades, I met success at flea markets and auction houses, with fellow collectors, and even several patients. And from such adventures, a pleasure garden of photographic memorabilia grew, out of which were harvested the pieces which make up *Photography Remembered: A Selective View.*

It is indeed a very special thrill for this grateful collector to be able to share his efforts in a publication and special exhibit so grandly presented by Curator of Photography Brooks Johnson and The Chrysler Museum. I hope the pages that follow will somehow enrich and expand your personal awareness of this visual gift from the sun, and in some small way, this gathering of material will feed a continuing interest in photography past and present.

<div style="text-align: right">

Robert Lisle
Sandy Brook, 1990

</div>

ACKNOWLEDGMENTS

To Curator of Photography, Brooks Johnson, for his relentless optimism and steadfast conviction that this project would be a success.

To Germaine Clair, for her wonderfully creative book design.

To Ronald Crusan, for his broad ranging assistance in producing this book and exhibit.

To Scott Wolff, for his exquisite photography.

To the rest of The Chrysler Museum staff, for their invaluable help and overall enthusiasm for this project.

To Mary Louise Schroeder and Jane Mangels, for their spirited willingness to type the original text for this book in addition to their usual duties at my office.

To Matthew Benedict, for his generosity in loaning me some previously owned pieces for this exhibit.

To Fred Rouleau and Fred Kost – two "old timers," for the magical excitement they created in me when I began collecting.

To the many people from whom I obtained material for this collection, for being there at the right place at the right time.

To my whole family, for indulging me the time and the freedom to pursue this sometimes solitary and exclusionary undertaking.

And finally, and most especially, to Nancy – my wife, who not only encouraged me to pursue this venture, but also provided invaluable advice and companionship along the way.

R. L.

BEFORE
PHOTOGRAPHY

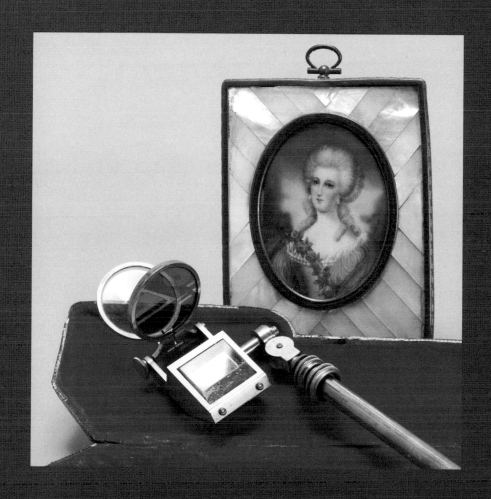

PICTORIAL REPRESENTATION

Before photography, the pictorial recording of reality depended on the interpretive view of the artist and his skill in transferring his subject to paper and canvas.

Forms of pre-photographic portraiture included the painted portrait, a cheaper kind of likeness called the silhouette and a mechanically derived rendering called the physionotrace.

THE PAINTED MINIATURE PORTRAIT

A miniature is a small painted portrait, usually in a locket or small frame. Until the introduction of photography, a miniaturist could earn a respectable living painting these small likenesses. The artists often were itinerant and would move from town to town answering the constant demand for portraits.

With the coming of the daguerreotype in 1839, this sizable troop of painters and their art form all but disappeared.

Christopher Greiner, American (active 1837-d. 1864)
Profile of a Man, ca. 1838
Oil on paper, 2¼" x 2"

Portrait of a Man, ca. 1830
Oil on paper, 2⅜" x 2"

Portrait of a Man, ca. 1830
Oil on paper, 2⅜" x 2"

Hoffinger (dates unknown)
Portrait of a Woman, ca. 1830
Oil on paper, 3¼" x 2½"

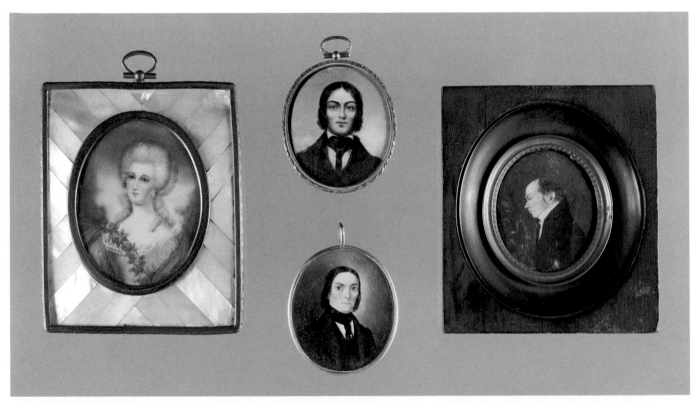

Group of Four Miniatures. Left, Hoffinger, *Portrait of a Woman;* ca. 1830; center, two male portraits by unknown artists, ca. 1830; right, Christopher Greiner, *Profile of a Man,* ca. 1838.

THE SILHOUETTE
Silhouettes of a Family, 1838
Paper, 15½″ x 12½″

Lt. Haslam, Worcestershire Militia, 1790
Paper, 4″ x 3″

Norman Rockwell, American (1894-1978)
The Colonial Silhouette Artist, ca. 1931
Lithograph, 17½″ x 13½″

THE PHYSIONOTRACE
Sometimes scientific exactitude was required of the portraitist. In 1784 J. K. Lavater, a cellist in the Versailles Palace orchestra, invented the physionotrace – a mechanical system for drawing profiles, which promoted a new standard of accuracy that was not exceeded until photography became available in 1839. The physionotrace was a portrait executed with a simple device that transferred the outline of the face onto a piece of paper. A second procedure reduced the size, which then was engraved.

Edme Quenedey, French (1756-1830)
Portrait of a Man, ca. 1780
Engraving, 3¾″ x 4″

3

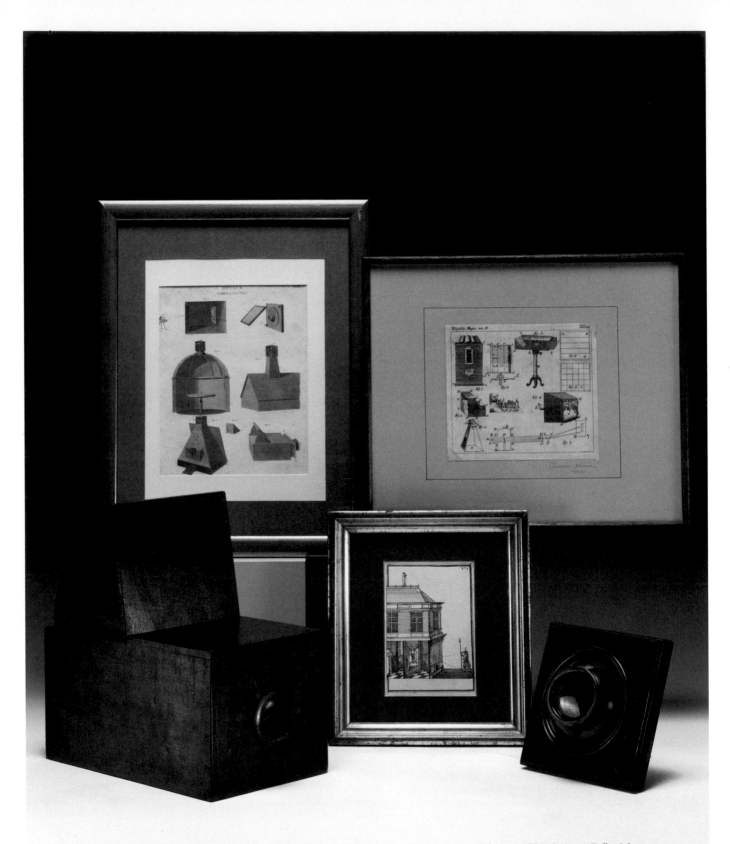

From top left: *Optics, Camera Obscura,* 19th century; *Early Pre-Photographic Optics, Camera Obscura,* 1798; *Scioptric Ball,* 18th century; *The Principle of the Camera Obscura,* 18th century; *Camera Obscura,* ca. 1830.

PRE-PHOTOGRAPHIC OPTICAL DEVICES

The ability to draw was a requisite talent for the complete gentleman in the days prior to photography. Early instruments were designed to assist in making and viewing sketches. The portable camera obscura, zograscope, scioptric ball and camera lucida were the precursors of the photographic camera.

The Zograscope, ca. 1800
Wood and glass, 27″ x 11″ x 2″
This pre-photographic optical device was intended for viewing prints in magnified form, using a lens and an angled mirror. It was also used by nearsighted people who, according to conventions of 18th-century society, would not wear spectacles in public. Later models represented novel Victorian parlor toys.

Vue Perspective, ca. 1800
Engraving, 12½″ x 17½″
This hand-colored French engraving, with the picture and title running in reverse, was made specifically for viewing through the zograscope.

Camera Lucida, ca. 1820
Brass and glass, 13″ x 3½″ x 2″
A significant invention that preceded photographic portraiture was the camera lucida, invented by W. H. Wollaston (1766-1828) in 1807. It was an optical instrument used as an aid in sketching. Actually not a camera at all, it used a prism to project an image onto paper. The artist would then trace the accurate outline. It was this instrument that so frustrated William Henry Fox Talbot that he turned with renewed interest to the camera obscura and the problem of fixing its images on chemically treated paper.

THE CAMERA OBSCURA

The dream of fixing the images created by the sun is as old as man's recognition that light passing through a small opening in the wall of a darkened room creates an inverted image on the opposite wall.

Aristotle (384-322 B.C.) recognized and recorded this phenomenon when he used it to protect his eyes while observing the eclipse of the sun. Centuries later, Leonardo da Vinci (1452-1519) described it in 1490. But it was the Neapolitan scientist, Giovanni Battista Della Porta (1538-1615), who in his widely known book on natural magic, *Magiae Naturalis* (1558), popularized the basic principle of the camera obscura.

A portable version of the camera obscura was described and illustrated by German scholar Athanasius Kircher in 1646. It had a lens to gather more light and sharpen detail, a translucent paper screen for viewing and a reflex mirror to right the inverted image.

The optical essentials and structural design of the photographic camera were now in place. The final step necessary to deliver photography to the world was to chemically fix the image of the camera obscura on paper.

Camera Obscura, ca. 1830
Wood and glass, 6½″ x 7″ x 11½″
This style of camera obscura first was described in the 16th century as a transportable sketching apparatus. This mahogany example, made in America, predates photography's invention. Such a device, equipped with a simple meniscus lens, an angled mirror and a focusing screen, was used in early photochemical experimentation. An image was projected to be traced or, in the case of photographic experiments, recorded on chemically treated paper or metal.

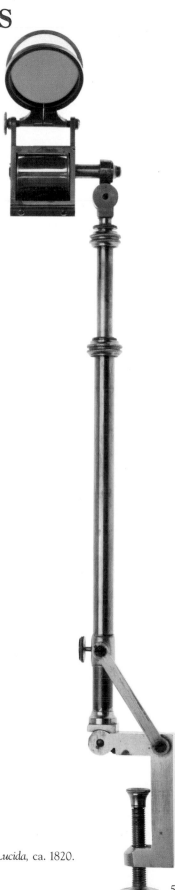

Camera Lucida, ca. 1820.

Scioptric Ball, 18th century
Wood and glass, 6½″ x 6½″ x 3½″
In 1636, a German mathematician described a wooden ball with a hole bored through it and a lens fitted on each end. It could be placed in the opening of the camera obscura, projecting a brighter, more detailed image. The scioptric ball was used for popular entertainment and as a sketching aid in mural painting.

Early Pre-Photographic Optics, Camera Obscura, 1798
From *Die Naturliche Magic* by Johann Christian, Wieglet, Berlin
Woodcut, 6½″ x 7¼″

The Principle of the Camera Obscura, 18th century
Woodcut, 6⅛″ x 4¼″
An early woodcut depicting a dark room (camera obscura) with a tiny hole in one wall through which the view outside is projected upside down on the opposite wall.

Optics, Camera Obscura, 19th century
Engraving, 9¼″ x 7⅜″

THE SEEDS OF PHOTOCHEMISTRY

In 1725 a German professor of anatomy, Johann Heinrich Schultz (1687-1744), accidentally discovered the most fundamental of photochemical phenomena – the magical relationship between light and silver. He recognized that it was not the action of heat, as was long believed, but the action of light that darkened the silver salts. Schultz placed paper figures on the outside wall of a flask containing a silver salt mixture and exposed the flask to light. The flask darkened except for those areas protected by the paper figures, leaving evanescent white designs for as long as the flask was kept from the sun. These first photograms were the seeds from which subsequent photochemical refinements grew. Some have argued that Schultz deserves to be recognized as the inventor of photography.

The idea of using the camera obscura to focus an image, then employing the light-sensitive property of silver to record it belongs to Thomas Wedgwood (1771-1805), the son of the famous British potter. Around 1800, Wedgwood and a fellow scientist, Sir Humphry Davy (1778-1829), were able to register an image on paper saturated with a silver nitrate solution using the camera obscura. Unfortunately, these men failed in their attempts to permanently fix the fleeting images. The world would wait another quarter century for the first permanent photograph.

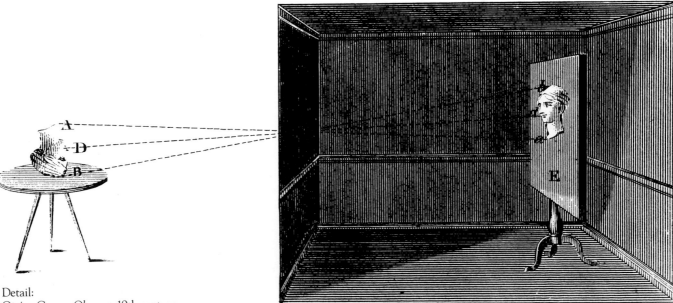

Detail:
Optics, Camera Obscura, 19th century.

THE
INVENTION

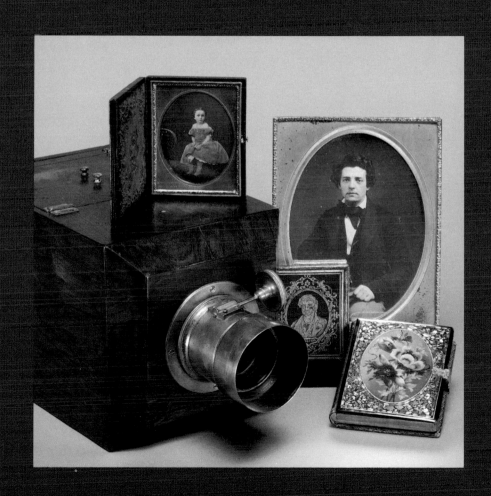

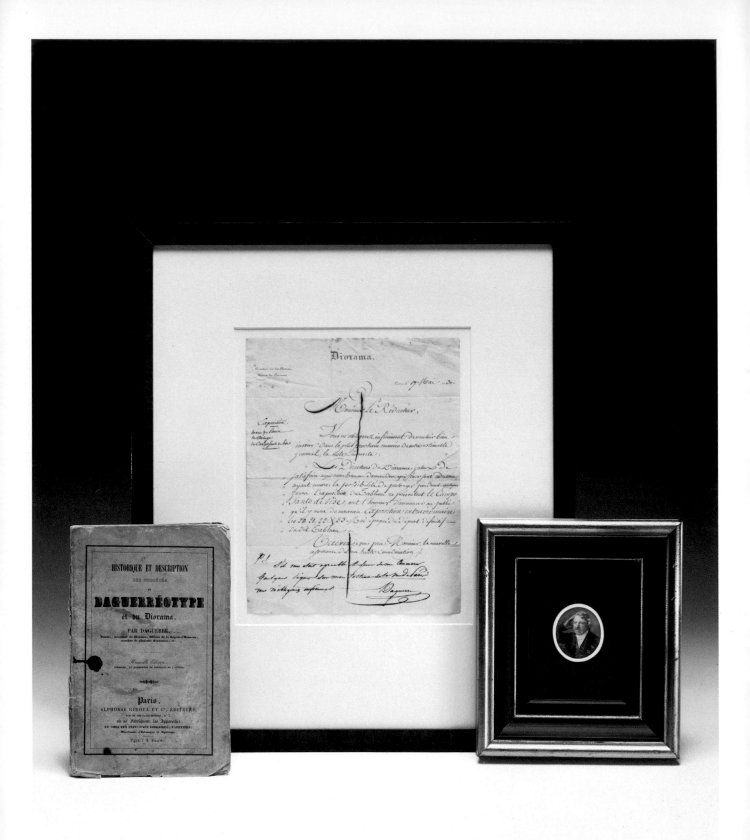

Historique et Description des Procedes du Daguerreotype et du Diorama, par Daguerre, 1839;
Diorama Letter, signed by Daguerre, May 17, 1830; John James Edwin Mayall, *Holotype Portrait of Daguerre*, 1900.

PHOTOGRAPHY IS BORN

When the age is fully ripe for any great discovery, it is rare that it does not occur to more than a single mind.

Edward Anthony, 1849
On the discovery of photography

The year was 1839 and the time was ripe for photography. The work of countless inventors, spanning centuries of experimentation, would finally coalesce. History credits a single man with the introduction of a practical way to permanently fix the image of the camera obscura. That man was Louis Jacques Mandé Daguerre. The daguerreotype captured the enthusiasm of an eager public and reigned supreme for more than a decade.

THE PIONEERS

LOUIS JACQUES MANDE DAGUERRE
John James Edwin Mayall, American (active Philadelphia 1840-1846, active England 1846-d.1901)
Holotype Portrait of Daguerre, 1900
Engraving from daguerreotype dated 1846, 1⅞" x 1⅝"
The man who introduced photography to the world was a self-educated Parisian named Louis Jacques Mandé Daguerre (1787-1851). He held a broad repertoire of talents: ballet dancer, assistant designer of the Paris Opera House, co-inventor of the diorama, painter and tightrope walker. Additionally, Daguerre feverishly pursued the solution to preserving the images made with a camera obscura.

In 1826 he learned from optician Charles Chevalier (1804-1859) that Joseph Nicéphore Niépce (1765-1833) shared a similar interest. Daguerre immediately wrote to Niépce requesting a rendezvous. After an investigation of Daguerre's qualifications, Niépce agreed to a meeting in Paris late in 1827. Despite a wide difference in social background, the two apparently got along and exchanged much information during that first meeting. By 1829, Niépce had overcome his original caution and invited Daguerre into partnership in the pursuit of what had become a common passion. Daguerre accepted, traveling to Niépce's country estate outside of Paris to learn the details of heliography (sun-drawing).

The partnership flourished until the untimely death of Niépce four years later. Although the men worked separately, Daguerre in Paris and Niépce at his home in Chalon, frequent communications by mail had kept each informed of the other's progress. By 1835, two years after Niépce's death, Daguerre perfected the photographic process that carries his name.

Without the knowledge provided by Niépce chances are Daguerre never would have discovered the final process that made him famous. It is no wonder that the Niépce family begrudged the disproportionate acknowledgement given to Daguerre.

Diorama Letter, signed by Daguerre, May 17, 1830
Ink on paper, 10" x 7¾"
Daguerre's diorama was a theater constructed to exhibit paintings by controlling the projection of daylight upon or through a canvas. It produced beautiful effects of light and shade and popularized many of Daguerre's paintings, bringing him international notoriety for 17 years. Ironically, it burned to the ground on March 8, 1839, while Daguerre was meeting with Samuel Morse to demonstrate his photographic process.

Historique et Description des Procedes du Daguerreotype et du Diorama, par Daguerre, 1839
Alphonse Giroux and Company, Paris
This is the French version of Daguerre's instruction booklet, which introduced photography to the world. Daguerre was an opportunist with a sense of timing

L. Palmer, *Painters Wept,* ca. 1925. This pen and ink watercolor of two cupids and a camera illustrates the triumphant birth of photography and the sadly anticipated demise of portrait painting.

and economics. He sold the rights to his invention to the French government in exchange for a lifetime pension. With equal cunning, the government reasoned that if it shared Daguerre's discovery by disseminating his instructional manual, the process would be perfected more rapidly. Indeed, the manual sold out of 29 editions in six languages the first year! This captivating form of photography raged through Europe and America like no other invention had before.

In America, the daguerreotype reached its peak in popularity by 1853. An estimated 10,000 daguerreotypists produced more than three million daguerreotypes that year. New York alone boasted more than 100 studios.

The uniqueness, and to many the disadvantage, of the daguerreotype was that it was a direct positive image; there was no negative from which to make multiple images. It had to be viewed at a particular angle to be seen clearly, and the fragile nature of the image surface required that it be encased and covered in glass.

The daguerreotype waned in popularity in the late 1850s. It was gradually replaced with new collodion techniques by 1860.

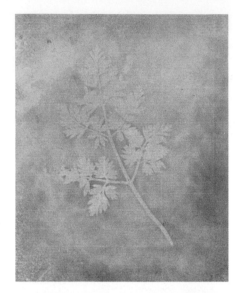

WILLIAM HENRY FOX TALBOT

Fern Leaf, ca. 1840
Positive and negative of a photogenic drawing
Two images, each 4½″ x 3½″

While vacationing in Italy in 1833, William Henry Fox Talbot (English, 1800-1877) made several frustrating attempts at drawing with the camera lucida. Talbot, working independently of Daguerre and Niépce, began experimenting with the "charming idea" of preserving images made by a camera obscura. Talbot picked up where Thomas Wedgwood left off 30 years before. He coated writing paper with a solution of common table salt and allowed it to dry. The dried paper was then brushed with silver nitrate, forming a light-sensitive coating of silver chloride. When exposed to light, the paper on which Talbot laid various delicately patterned objects recorded a reversed facsimile, or negative, of the various configurations. After fixation of the negative with a saturated solution of table salt, Talbot laid the paper with the reversed image on another sheet of sensitized paper and, after adequate exposure to the sun, produced a true facsimile, or positive image. By 1835, Talbot had adapted this positive-negative process to be used in a camera obscura and was actually able to record scenes from nature. Talbot called his images calotypes, a derivation of the Greek words meaning "beautiful impression."

When word of Daguerre's announcement reached Talbot, he delivered a hurried summary of his own work in January 1839. His treatise on photogenic drawing left the public unimpressed. Talbot further restricted the use of his invention by patenting the Talbotype in 1841.

In 1842 Talbot published the first photographically illustrated book, *The Pencil of Nature,* a collection of 24 calotype prints of various subjects. By this time the calotype represented a reasonable alternative to the daguerreotype, with the distinct advantage of being able to produce multiple prints from a single negative easily and cheaply. Yet even with numerous refinements, the calotype never rivaled the popularity of the daguerreotype.

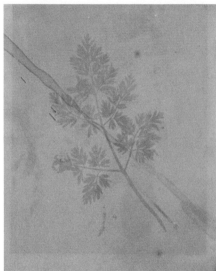

William Henry Fox Talbot, *Fern Leaf,* positive and negative, ca. 1840.

Letter, signed H. F. Talbot, 1837
Ink on paper, 9″ x 7¼″

Articles of China, plate III from *Pencil of Nature,* 1844
Talbotype, 5¼″ x 7″
Talbot recognized the value of photography as an inventory tool, should a "thief purloin your treasures."

Lacock Abbey, plate XV from *Pencil of Nature,* 1844
Talbotype, 5¾″ x 7¾″
In Wiltshire, Lacock Abbey was the beautiful country estate that Talbot inherited. Talbot stated: "In my first account of *The Art of Photogenic Drawing,* read to the Royal Society in January 1839, I mentioned this building as the first that was ever yet known to have drawn its own picture." It was in the summer of 1835 that these curious self-representations were first obtained.

Portrait of a Man, ca. 1840
Talbotype, 3¾″ x 2¾″
Talbot on portraiture: "When the sun shines, small portraits can be obtained by my process in one or two seconds, but large portraits require a somewhat longer time. When the weather is dark and cloudy, a corresponding allowance is necessary and a greater demand is made upon the patience of the sitter."

SAMUEL F. B. MORSE
Abraham Bogardus, American (1822-1908)
Samuel F. B. Morse, ca. 1864
Albumen print, 5¼″ x 3¾″
Samuel F. B. Morse (1791-1872), considered the father of American photography, was a leading American painter who experimented with the camera obscura but gave up on the possibility of fixing its image permanently. In Paris to patent his telegraph invention in 1839, Morse sought a meeting with Daguerre. He was the first American to witness the wonders of the daguerreotype.

Morse wrote to his brother on March 9, 1839 that no painting or engraving had ever approached the exquisite results of the daguerreotype. He called it "one of the most beautiful discoveries of the age." This letter was published in New York on April 20, 1839, and represents America's first knowledge of photography. Morse proceeded to master the art of making daguerreotypes, opening a daguerreian portrait studio in New York City in 1840. To support his painting career, Morse became a teacher. Most notable of Morse's students were Edward Anthony, Mathew Brady and Albert Southworth.

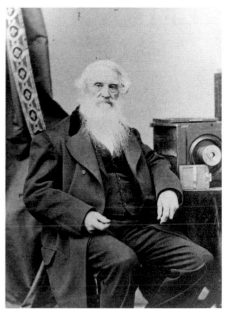

Abraham Bogardus, *Samuel F. B. Morse,* ca. 1864.

COLLATERAL MATERIAL
"Photogenic Drawing," *The Saturday Magazine,* April 1839
John William Parker, editor, London, bound copy, January-June 1839
This article discusses the discovery of photography and Daguerre's and Talbot's contributions:

> . . . for the object which would take the most skillful artist days or weeks of labour to trace or to copy, is effected by the boundless powers of natural chemistry in the space of a few seconds. . . . All that is fleeting and momentary, may be permanently fixed in position which it seemed only destined for a single instant to occupy.

Not all the civilized world greeted photography with enthusiasm. In 1839, the German publication *Leipziger-Stadtanzeiger* wrote:

> The wish to capture evanescent reflections [in the camera obscura] is not only impossible . . . but . . . is blasphemy. . . . No man-made machine may fix the image of God. Is it possible that God should have abandoned His eternal principles, and allowed a Frenchman in Paris to give the world an invention of the Devil? [Daguerre] wants to outdo the Creator of the world.

"Pencil of Nature – a New Discovery," *Corsair,* 1839
N. T. Willis and T. O. Porter, editors
Corsair, Astor House, New York
This article discusses the rivalry of Daguerre's and Talbot's processes, the supplanting of other arts by photography and notes Talbot's letter to the editor of the *Literary Gazette* recounting his experiments of 1834 concerning:

> . . . the art of photogenic drawing, or of forming pictures and images of natural objects by means of solar light . . . [and that] all nature shall paint herself . . . at a bidding, and at a few moments notice . . . by virtue of the sun's patent, animate and inanimate, shall be henceforth its own painter, engraver, printer, and publisher. . . Mr. Daguerre's invention is instantly rivalled by Mr. Fox Talbot's . . . the Daguero-scope and the Photogenic revolutions are to keep you all down, ye painters, engravers, and, alas! the harmless race, the sketchers.

L. Palmer, American (1893-?)
Painters Wept, ca. 1925
Ink and watercolor, 5¼″ x 6¼″

THE DAGUERREIAN PERIOD

THE DAGUERREOTYPE – THE MIRROR WITH A MEMORY

Aptly likened to a mirror with a memory, a daguerreotype does, in fact, resemble a mirror when viewed from one angle and a haunting portrait when viewed from another. No wonder this luminescent gem was the first photographic image to enjoy broad popularity. A fine daguerreotype's mysterious brilliance and exquisite detail rivals the appeal of any other photographic method.

Having a daguerreotype made was no small undertaking. Usually dressed in those inflexible Sunday bests, one had to be prepared to remain motionless for almost a minute under the blazing brightness and heat of direct sunlight. To discourage movement, the subject's head was placed in a semi-circle of iron. It is no wonder smiles are the exception during the daguerreian period!

Daguerreotypes were made by fuming a polished silvered copper plate with the vapors of iodide, rendering the plate light-sensitive. After exposure in the camera, often a minute or more, the plate was developed into a positive image by placing it in a chamber containing heated mercury. Fixation followed, employing a ten percent solution of hot sodium thiosulfate which dissolved the silver halide salts that were not altered by light. The image that remained was a white amalgam of mercury and exposed silver on a dark background. The amount of mercury amalgamated with silver at each point on the image varied directly with the amount of light that struck the point. The plate was washed with distilled water and dried with gentle heat. The image was usually intensified with a gold solution, which darkened the silver background and rendered the mercury amalgam even lighter.

IMAGERY

William Langenheim, American, b. Germany (1807-1874)
Frederick Langenheim, American, b. Germany (1809-1879)
Painting of a Lady, ca. 1842
Daguerreotype, 4¾" x 3½"
A daguerreotype of a painting attributed to portrait painter Thomas Wilcocks Sully (1811-1847). Pad embossed "W. & F. Langenheim – Philadelphia Exchange." The Langenheims opened a daguerreotype studio at the Exchange in Philadelphia in 1841 or 1842 and purchased the U. S. patent to make Talbotypes in America in 1849. They were also pioneers of stereo photography.

James Marsters (active Baltimore, Maryland 1840s)
Alma Whitridge and Her Faithful Nurse Patty Ativis, 1848
Daguerreotype, 3½" x 2⅝"
Alma was a relative of Thomas Worthington Whittredge (1820-1910), a distinguished American landscape painter who as a young man worked in a daguerreotype studio in Indianapolis.

John Plumbe, Jr., American, b. Wales (1809-1857)
Young Man, ca. 1842
Daguerreotype, 2¾" x 2¼"
John Plumbe was an early daguerreotypist and photographic entrepreneur who opened a daguerreian gallery in Boston in 1840. Within five years he owned 14 studios and supply houses across the country from Boston to St. Louis. No doubt overextended, Plumbe declared bankruptcy in 1847. After frustrated attempts to realize his dream of a transcontinental railway, he committed suicide.

Albert Sands Southworth, American (1811-1894)
Josiah Johnson Hawes, American (1808-1901)
Portrait of Alice Syman, Age 3, 1855
Daguerreotype, 5" x 4"
The partnership of Southworth and Hawes, established in 1845, produced some of the most artistic daguerreian portraits known.

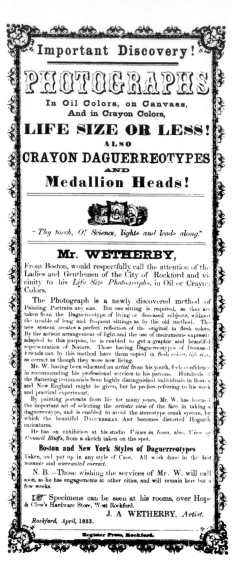

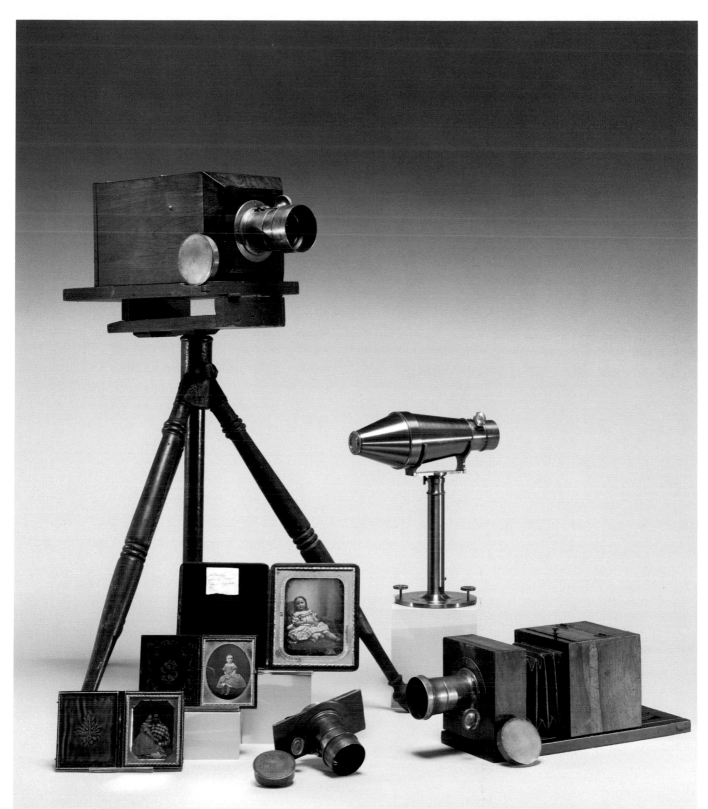

From top left: *Quarter-Plate Chamfered Camera*, ca. 1848 with *Tripod*, ca. 1845; *Conical Camera*, original 1841; *Sixth-Plate Lewis-Style Camera*, ca. 1855; John Plumbe, Jr., *Lens*, ca. 1845; Daguerreotypes: James Marsters, *Alma Whitridge and Her Faithful Nurse Patty Ativis*, 1848; Charles H. Williamson, *Portrait of a Young Girl*, ca. 1853; Southworth and Hawes, *Portrait of Alice Syman, Age 3*, 1855.

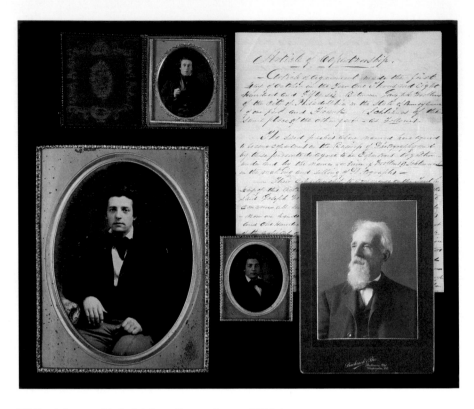

Joseph Woollens and Frank Schleunes. Frank Schleunes was a German immigrant who entered the business of making and selling photographs in 1856 with a daguerreian case-maker named Joseph Woollens. This cache of related items was a gift from Schleunes' granddaughter. Clockwise from top left: *Joseph Woollens*, 1856; *Article of Co-Partnership*, 1856; [David] Bachrach and Brothers, *Frank Schleunes as a Elderly Man*, 1915; *Frank Schleunes*, 1856; *Frank Schleunes*, 1856.

Willard (active Philadelphia, Pennsylvania 1850s)
Young Man, ca. 1856
Daguerreotype, 1¼″ x 1″

Charles H. Williamson, American (active 1850s)
Portrait of a Young Girl, ca. 1853
Daguerreotype, 3½″ x 2¾″
Williamson was renowned for his fine daguerreian portraits of young children.

Joseph Woollens (active Philadelphia, Pennsylvania 1852)
Frank Schleunes (1833-1921)
Article of Co-Partnership, 1856
Letter, ink on paper, 10″ x 8″

Joseph Woollens and Frank Schleunes
Frank Schleunes, 1856
Daguerreotype, 7¼″ x 5⅜″

Joseph Woollens and Frank Schleunes
Frank Schleunes, 1856
Daguerreotype, 2⅝″ x 2⅛″

Joseph Woollens and Frank Schleunes
Joseph Woollens, 1856
Daguerreotype, 2⅝″ x 2⅛″

[David] Bachrach and Brothers, American, b. Germany (1845-1921)
Frank Schleunes as an Elderly Man, 1915
Gelatin-silver print, 5¼″ x 3¾″

Lady in Furs, ca. 1848
Daguerreotype, 2¾″ x 2¼″

Mother and Two Daughters, ca. 1855
Daguerreotype, 2″ x 1½″

Young Lady, ca. 1850
Daguerreotype, 1½″ x 1¼″

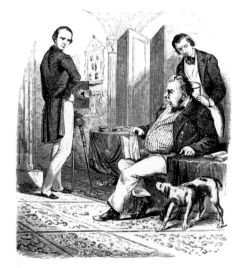

THE DAGUERREOTYPIST.

The Daguerreotypist, from *Godey's Lady's Book*, 1849. A woodcut picturing the photographer at work with an unhappy and uncomfortable subject.

Portrait of a Woman, ca. 1845
Daguerreotype, 2⅝" x 2⅛"

Man with Crossed Arms, ca. 1850
Tinted daguerreotype, 2¼" x 1¾"

Portrait of a Man, ca. 1850
Daguerreotype, 3⅝" x 2⅝"

Mother with Daughters in Blue Dresses, ca. 1850
Daguerreotype, 2¾" x 2¼"

APPARATUS

Voigtländer, Germany
Conical Daguerreian Camera (replica), original 1841
Brass and glass, 12" x 14" x 5"
To commemorate Voigtländer's 200th anniversary in 1956, a limited edition of
approximately 200 reproductions of the original model were made. The
Voigtländer camera was equipped with a 3.6-aperture lens, which markedly
reduced exposure time. The Langenheim brothers were the American agents
for the camera, which sold in 1843 for $275.

Sixth-Plate Lewis-Style Daguerreian Camera, ca. 1855
Wood, brass and glass, 7" x 6" x 20"
A rosewood veneered sixth-plate camera equipped with a Holmes, Booth and Hay-
den Lens. The use of a bellows in a photographic camera was patented by W. and
W. H. Lewis in 1851.

Quarter-Plate Chamfered Daguerreian Camera, ca. 1848
Rosewood, brass and glass, 8" x 7½" x 17"
The classic American daguerreotype camera. This example took quarter-plates and
smaller. There is an internal sliding box for focusing.

Fuming Box, ca. 1850
Wood, 8" x 14" x 5½"
For sensitizing daguerreian plates with the iodide vapors.

Plate Box, ca. 1850
Wood, 7" x 5⅛" x 4½"
For storing half-plates.

Plate Vise (replica), original 1850
Wood, 14½" x 2" x 6"
Holds daguerreotype plates for easy polishing.

Buffing Stick (replica), original 1850
Wood and leather, 2" x 4½" x 26½"
For polishing daguerreotype plates.

The Hess Improved Head Clamp, 1880
Iron, 45" x 16½"
The long exposure times needed for photographic portraiture required immobiliza-
tion of the subject's head with such a device. Its cold grip and formidable
appearance contributed to the unhappy faces so often seen in early portraits.

Daguerreian Tripod, ca. 1845
Iron and wood, 40" x 27" x 28"

John Plumbe, Jr., American, b. Wales (1809-1857)
Daguerreian Lens, ca. 1845
Brass and wood, 5" x 6¼" x 4"
Marked "Plumbe – New York – Paris – #273."

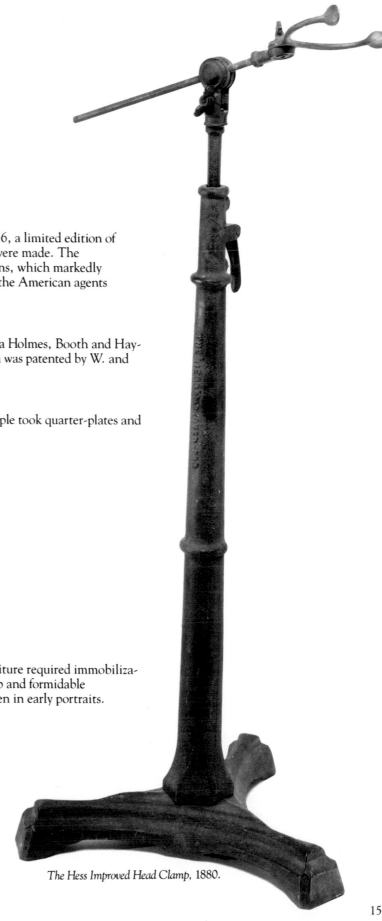

The Hess Improved Head Clamp, 1880.

COLLATERAL MATERIAL

Isaac Augustus Wetherby, American (1819-1904)
Daguerreian Broadside, 1855
Ink on paper, 12" x 6"
"Mr. Wetherby from Boston" announces his arrival in Rockford and his newly dis-covered method of painting portraits, "Life Size or LESS."

Edward Anthony, American (1818-1888)
Daguerreian Advertising, ca. 1852
Ink on paper, 7½" x 5"
Edward Anthony was a pioneer daguerreotypist and the premier importer and manufacturer of daguerreotype materials in America. His establishment at 308 Broadway, New York, was called the National Daguerreian Depot.

The Daguerreotypist, from *Godey's Lady's Book*, 1849
L. A. Godey, publisher and editor, Philadelphia, Pennsylvania
Ink on paper, 6¼" x 4¾"

The Daguerreotype, volume I, 1847
J. M. Whittemore, publisher, Boston
Ironically there is no mention of photography in the entire volume. Daguerreotype had become a household word, perhaps suggesting the "truth" of the magazine's contents.

George M. Hopkins (dates unknown)
"Reminiscences of Daguerreotypy," *Scientific American*, volume LXI, number 4, January 22, 1887
Scientific American, Inc., New York
Although the daguerreotype was obsolete by 1887, this article commemorated it and outlined the process.

The Daguerreian Artist, ca. 1855
Ambrotype, 4⅝" x 3⅛"
This photographer is seated beside a half-plate Lewis-style daguerreian camera.

S. Wing Daguerrian Gallery, Waterville, Maine, original image ca. 1855
Contemporary gelatin-silver print, 8" x 10"
Note the skylight in the roof. Simon Wing was not only a photographer but also an inventor of a number of ingenious camera designs.

The Traveling Photographic Saloon, original image ca. 1855
Contemporary gelatin-silver print, 8" x 10"
Many early photographers were itinerant practitioners of the art and would move their mobile gallery from town to town in search of business.

DAGUERREIAN CASE ART

Henry A. Eichmeyer, American (active Philadelphia, Pennsylvania 1850s)
Daguerreotype Case, 1848
Leather and wood, 2" x 1⅞" x ⅝"

William Shew, American (1820-1903)
Daguerreotype Case, ca. 1845
Leather and wood, 3¾" x 3¼" x ¾"
Interior label reads: "Wm. Shew, Miniature Case Maker and Dealer in Daguer-reotype Apparatus and Materials, Court Street Opposite the Head of Hanover St. Boston."

Wolfert's Roost Daguerreotype Case, ca. 1853
Leather and wood, 3" x 3⅝" x ¾"
Washington Irving's residence along the Hudson River, Sunnyside, was once called Wolfert's Roost.

Daguerreotype Case with Imprint "Daguerre," ca. 1848
Leather and wood, 3¾" x 3¼" x ¾"

James W. Williams, *Portrait of an Elderly Gen-tleman*, ca. 1855. Taken from a daguerreotype and hand-colored at the artist's emporium.

Arabesque Motif Daguerreotype Case, ca. 1858
Leather and wood, 4¾″ x 3¾″ x ¾″

Peter E. Gibbs (active Richmond, Virginia 1850s)
Daguerreotype Case, ca. 1851
Velvet and wood, 4¾″ x 4″ x ⅞″
Interior pad reads "Whitehurst Galleries – New York, Baltimore, Richmond, Norfolk, Petersburg & Lynchburg."

Halvor Halvorson (dates unknown)
Daguerreotype Case, 1855
Steel and leather, patented 1856, 4″ x 3½″ x ¾″

Littlefield, Parsons and Company, Casemaker
The Chess Players, ca. 1856
Union Case, 2½″ x 3″ x 1″
Composition or Union cases, produced from sawdust, shellac and heat, were the first plastics. Manufactured from the early 1850s through the late 1860s, a great number of designs and thematic scenes were produced, reflecting the sentiments of the times.

Anthony Schaefer, Die Engraver, American (active 1850s-1860s)
Littlefield, Parsons and Company, Casemaker
The Pioneers, ca. 1856
Union Case, 6¼″ x 5″ x 1″

Geometric Design, ca. 1856
Union Case, Diameter 1¾″ x ½″

Floral Design Daguerreotype Case, ca. 1850
Papier-mâché and inlaid mother-of-pearl, 6¼″ x 5¼″ x 1″

Floral Design Daguerreotype Case, ca. 1855
Papier-mâché and inlaid mother-of-pearl, 4¾″ x 4″ x 1″

Civil War Soldier, ca. 1861
Gold locket-style case, diameter 2″ x ½″

Portrait of a Man, ca. 1858
Gold pendant case, diameter 3″ x ¼″

The fragile nature of the daguerreotype image necessitated some kind of protective casing. A wide variety of attractive cases was produced. The glass-covered daguerreotype plate, matted with a brass protector and jacketed around the edges with a gold-like foil, was placed luxuriously inside these lovely hinged book-style cases. The photographer's name often was impressed on the brass mat or the velvet pad opposite the image. Many designs and materials were used in producing these delightful Victorian cases. Back row: Velvet ca. 1851, Floral Design ca. 1850, *The Pioneers* ca. 1856, Floral Design ca. 1855, Arabesque Motif ca. 1858. Front: Leather 1848, "Daguerre" ca. 1848, *The Chess Players* ca. 1856, Wolfert's Roost ca. 1853, Geometric Design ca. 1856.

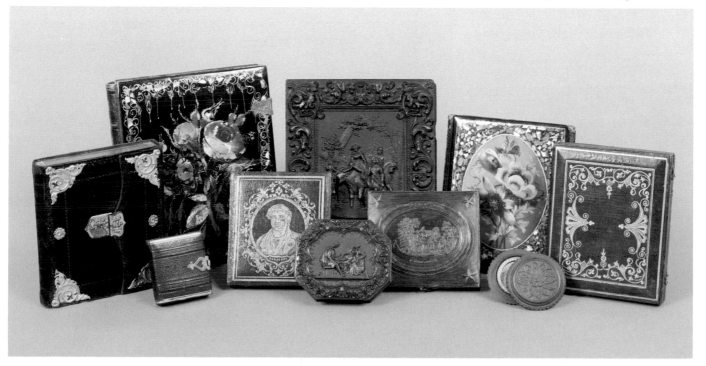

THE TALBOTYPE

Talbot's process more closely resembled modern photographic methodology than did Daguerre's. The small, fuzzy images required a lengthy exposure time and only a few artists found the calotype (Talbotype) to be a beautiful impression.

The cameras used for making calotypes were similar in appearance to those used for daguerreotypy. The only difference was the holder, designed to support a piece of paper rather than a copper plate. Talbot liked tiny pictures and had numerous cameras about the house; his wife uncharitably referred to the cameras as "mouse traps."

IMAGERY

Thomas Sutton, English (1819-1875)
Portrait of a Girl, ca. 1850
Tinted calotype, 5¼" x 4"
Marked: "Mr. Sutton Photographic Miniature 204 Regent St." Sutton was an enthusiast of the calotype as well as the daguerreotype. He was an inventor of numerous camera designs, including one of the first reflex cameras and a panoramic camera using a water-filled, wide-angle lens. He also published the first English dictionary of photography in 1858.

James W. Williams (dates unknown)
Portrait of an Elderly Gentleman, ca. 1855
Tinted Talbotype, 7¼" x 5¼"

James W. Williams
Talbotypes Taken from Daguerreotypes, ca. 1855
Broadside, ink on paper, 4¾" x 3¾"

Peregrine F. Cooper (active Philadelphia 1840-1890)
Rathwell Wilson, 1856
Painted Talbotype, 5" x 3¾"
The portrait is believed to be that of Rathwell Wilson, ship's chandler from Wilmington, Delaware. Peregrine F. Cooper published a book in 1863 called *The Art of Making and Coloring Ivory Types, Photographs, Talbotypes, and Miniature Painting on Ivory* by P. F. Cooper, Miniature, Portrait, Pastel, and Equestrian Painter and Photographer. He states in his introduction that he has had "the experience of twenty-three years in study and practice in miniature painting, twelve years of that time principally devoted to Talbotype, or photography and ivorytype coloring."

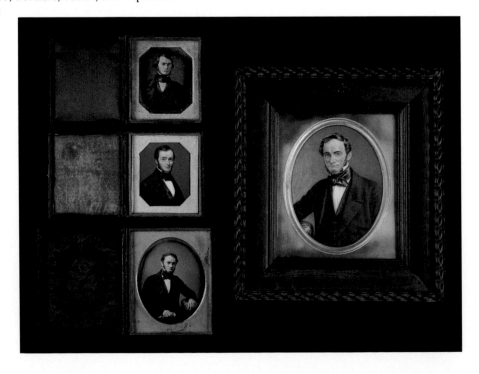

Rathwell Wilson, ca. 1845
Daguerreotype, 3½" x 2¾"
The preceding talbotype is a copy of this image.

Rathwell Wilson, ca. 1842
Daguerreotype, 2¾" x 2¼"

Rathwell Wilson, ca. 1845
Painted miniature, oil on paper, 2⅝" x 2⅛"

Rathwell Wilson was a gentleman who obviously enjoyed having his portrait made! The image on the right, a painted Talbotype (1856) is a copy of the bottom left daguerreotype (1845); the center image is a painted miniature (1845) and the top is an earlier daguerreotype (1842).

THE
EXPLOSION

THE WET-PLATE PROCESS

While calotypy had the advantage of multiple positives from a single negative, its characteristic haziness and the paper negative's fragility were regarded as distinct liabilities. Glass was considered an ideal backing for the photographic negative, but the problem of how to adhere the suspension of light-sensitive material to its surface delayed its implementation. Even the slime of a snail's footprint had been (unsuccessfully) tried by Claude Niépce de St. Victor (1805-1870), the nephew of Nicéphore Niépce, who eventually discovered that egg white (albumen) was the perfect binding agent. He spread a layer of the mixture over a glass plate, then dipped the plate (then dry) into a sensitizing bath of acidified silver nitrate, creating the light-sensitive crystals of silver iodide within the albumen layer. While still wet, the plate was exposed within the camera. Exposure times ranged from five to 15 minutes, significantly longer than for the calotype or daguerreotype. However, prints from the albumenized glass plate negative exhibited improved image quality and remarkable tonal range. Despite the long exposure time, the albumen method successfully promoted the use of the glass negative. Improvements that reduced exposure times made portraiture practical. Albumen print paper, conceived by Louis-Désiré Blanquart-Evrard (1802-1872), soon followed. Egg consumption boomed!

In 1851, four years after the introduction of the albumen plate, Frederick Scott Archer (1813-1857), an English sculptor and photographer, recognized that collodion was more suitable than albumen for holding the silver salts. Collodion is the product of combining guncotton (nitrocellulose and pyroxylin) with alcohol or ether; it is a clear viscous substance which dries into a hard transparent film. It was first used by physicians as a protective dressing for minor lacerations. Collodion became the hallmark of

Wet-Plate Apparatus. *Dipping Tank,* ca. 1865; *Ferric Hyposulfite,* ca. 1865; *Anthony's Negative Guncotton,* ca. 1865; *Collodion Bottle,* ca. 1865; *Square Jars,* ca. 1865; *Scale,* ca. 1865.

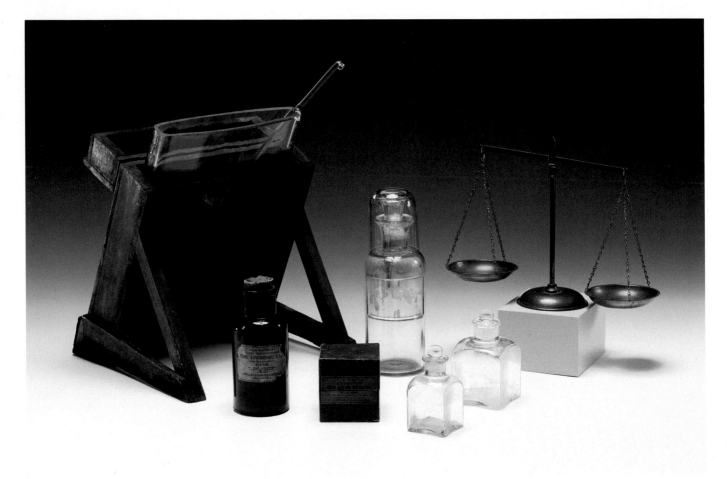

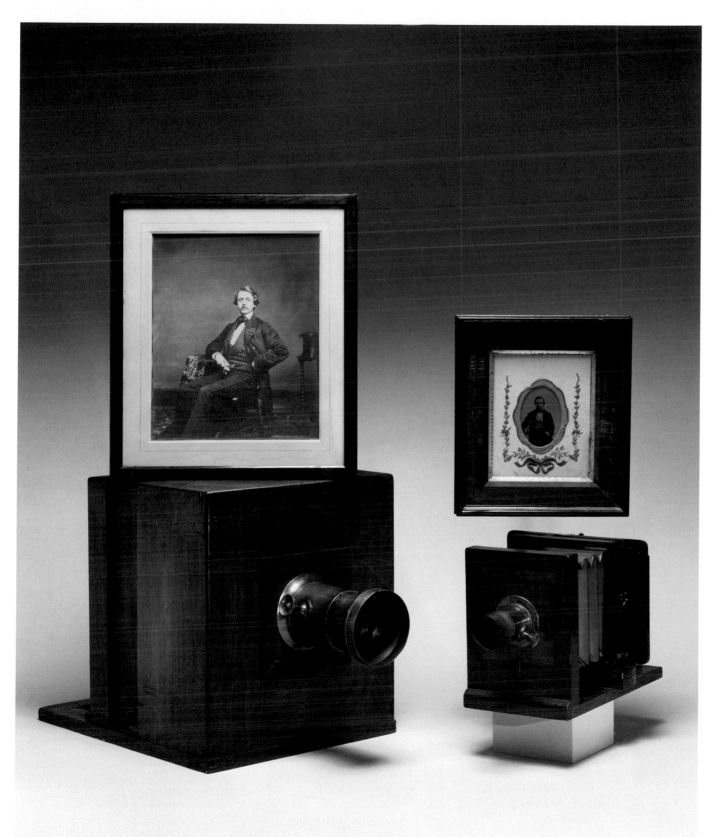

Left: *Mammoth Wet-Plate Camera*, ca. 1860; Charles A. Williamson, *Portrait of a Man*, salt print, ca. 1850.
Right: American Optical Company, *Half-Plate Ambrotype Camera*, ca. 1868; *Portrait of a Man*, ambrotype, ca. 1860.

the wet-plate period, quickly supplanting albumen. It yielded a much shorter exposure time (from five to 15 seconds) and remained in general use for 30 years.

To use the process, collodion was first salted with potassium iodide or bromide, and then layered onto a glass plate. While still tacky, the plate was dipped into a sensitizing bath of silver nitrate. After sensitization (formation of silver iodide and bromide crystals), the plate was placed wet into a light-tight holder and immediately exposed in the previously aimed and focused camera. Development with pyrogallic acid followed quickly thereafter. The time between the initial flowing of the collodion and development generally did not exceed ten minutes. Fixation was with sodium thiosulfate. Lastly, the negative was painted with a protective coating of clear varnish.

THE WET-PLATE PHOTOGRAPHER

It was no small undertaking to produce an image using the wet-plate method. The prerequisites of money, patience and brawn limited its widespread use. Only the professional devotee was willing to contend with the clumsy procedure. Traveling with hundreds of pounds of equipment on their backs or in special darkroom buggies, they ventured to the tops of mountains, into the heat of deserts and into the raging thick of two great wars. Their admirable ambition bequeathed to posterity an invaluable photographic documentation of the times and places they witnessed.

International Metal and Ferrotype Company, *The Diamond Gun Tintype Camera,* ca. 1913; Edward M. Estabrooke, *The Ferrotype and How to Make It, 1880; G. C. Poor, Well! Well! Well!,* ca 1900; *Montage of Gem Tintypes and Advertisements,* ca. 1870; *Hand-Crafted Tintype Camera,* ca. 1900; A. G. Metzger, tintypes, ca. 1890: *Undercover Agents, Portrait of a Man, Sudio Interior.*

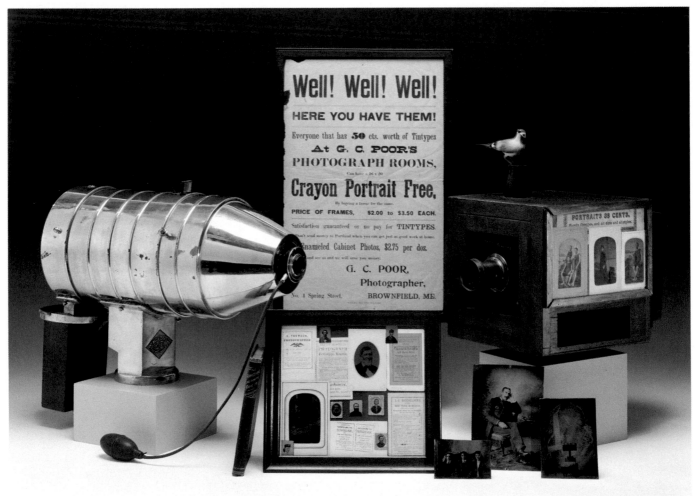

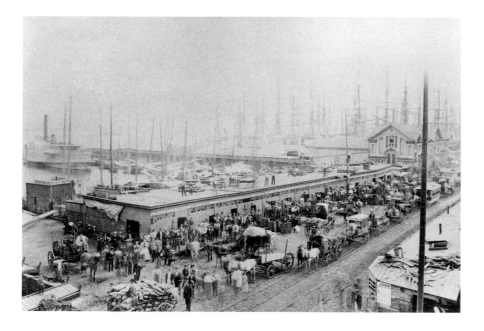

Fulton Street Ferry, albumen, ca. 1875. A flurry of commercial activity with the Fulton Street Ferry House in the background. Once the pride of the Union Ferry Company, it was constructed in 1871 and known as the "Great Gateway to Brooklyn" before the completion of the Brooklyn Bridge in 1883.

THE WET-PLATE CAMERA
Many of the wet-plate cameras built between 1854 and 1880 were of the view-type, with square bellows, hand-crafted woodwork and brass lenses without shutter mechanisms. A framed viewing glass, hinged to the rear of the camera, was swung away after focusing, allowing room for the light-tight holder containing the wet sensitized plate. Because of the dripping collodion, these cameras exhibit chemical stains in the rear corners as well as inside the plate holders. Glass plates were available in a variety of sizes similar to copper daguerreotype plates. Practitioners specializing in impressively big prints used a correspondingly large camera. Many cameras were built with several lenses, sometimes 12 or more, making it possible to take multiple images of the same subject on a single plate. Multiple lens cameras were especially popular among carte de visite photographers, who sold large numbers of prints of the same subject.

As the wet-plate period drew to a close, several mechanical provisions for aperture control were introduced. One was a rotating disc with various sized openings, which was inserted into the anterior of the lens barrel. By rotating the disc, one could place one of several apertures in front of the lens, controlling the amount of light entering the camera. Another device made use of keys containing holes of various sizes. A particular key was inserted into a slot in the lens barrel, thereby regulating incoming light.

IMAGERY
Several distinctly different types of photographs emerged during the wet-plate period; the use of collodion was their common characteristic.

Albumen and Salt Contact Prints, 1851-1880
A wet-plate print was only as big as its negative. The collodion or albumen negative was placed directly on sensitized albumen print paper and then exposed, developed and fixed. This method, known as contact printing, was used exclusively before the invention of the enlarger. Although most prints were standard sizes, paralleling the dimensions of daguerreotype plates, some very small and very large prints were also made during this period. One set of mammoth pictures required ten-gallon tanks for processing the huge glass negatives.

Salt prints were made with ordinary table salt. These prints lack a glossy surface and appear flat to the observer. Many were hand-colored, making them indistinguishable from paintings at times.

J. H. Beal (active New York, 1870s)
Watson Catlin Drugstore, New York, ca. 1870
Albumen print, 12½" x 16½"

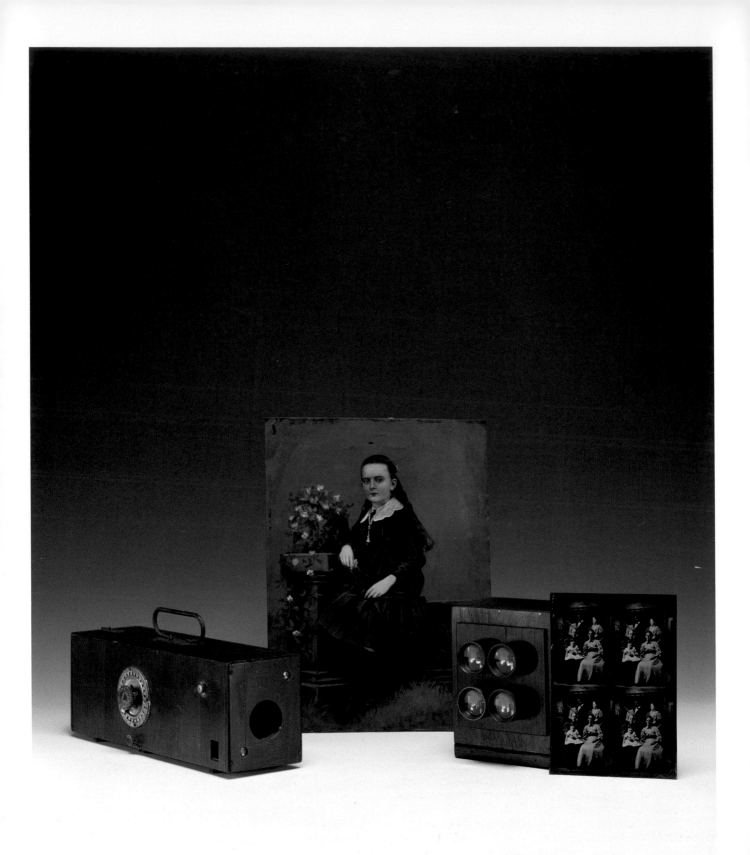

The Popular Photograph Company, *Nodark Tintype Camera,* ca. 1899, *Young Girl,* tintype, ca. 1890;
Four Tube Lens Set, ca. 1870; A. G. Metzger, *Uncut Multiple Exposure of a Family,* tintype, ca. 1890.

The Tintypist, Albumen print, ca. 1900. The proud photographer stands in front of his Victorian gingerbread studio with examples of his work.

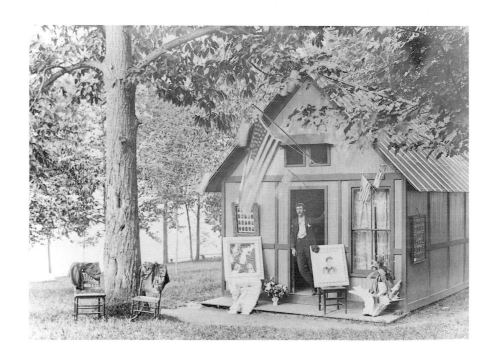

William Henry Jackson,
American (1843-1942)
Middle Creek, Mt. Blockmore, ca. 1870
Albumen print, 7⅝″ x 11⅝″
Perhaps the best known American landscape photographer, Jackson opened the eyes of Congress to the majestic beauty of the American West and influenced the institution of a National Park Service. This particular view pictures a small encampment, with Jackson's dark tent and supplies under a distant tree.

Frank M. Sutcliffe, English (1853-1941)
Harbor Scene, Whitby, England, ca. 1885
Albumen print, 4½″ x 7½″
Sutcliffe spent most of his life in the Yorkshire coastal town of Whitby, where he established a studio. One of his personal interests was photographing harbor scenes.

Isaiah West Taber, American (1830-1912)
Mirror Lake, Yosemite Valley, California, 1882
Albumen print, 7¼″ x 9½″
A noted California photographer, Taber had a varied career as a gold miner, rancher, writer and dentist before settling on photography. He opened a gallery in San Francisco in 1871.

Charles A. Williamson, American (active 1850s)
Portrait of a Man, ca. 1850
Salt print, 16″ x 13″
This mammoth-sized salt print of a young dandy demonstrates Williamson's talents beyond his established reputation as a premier daguerreotypist.

Homes of American Statesmen with Anecdotal Personal and Descriptive Sketches, 1854
G. P. Putnam and Company, New York
Mounted frontispiece is a crystallotype or sun picture by John Adams Whipple (1823-1891) of the Hancock House in Boston. This was the first American book with an original photographic print tipped in. Whipple's crystallotype process, patented June 25, 1850, consisted of a mixture of albumen, pure liquid honey, potassium iodide, potassium bromide and sodium chloride.

Portrait of a Man, ca. 1855
Oil on salt print, 14¾″ x 11¾″
This heavily painted salt print resembles a painting more than a photograph.

Fulton Street Ferry, ca. 1875
Albumen print, 10½″ x 15¾″

The Carte de Visite, 1854-1880

These pocket-sized photographs were 2″ x 3″ mounted prints, most often portraits, which were used as calling cards during the latter part of the 19th century. Their success as a form of social currency followed an opportunistic portrait photographer named Disderi (1819-1890) who photographed Napoleon III using this format. The result was overnight popularization. Disderi and his assistants soon were producing $800 worth of these photographs per day at about $5 for a dozen duplicates from a single negative.

William H. Gilhousen, Artist, Kahoka, Missouri
Self Portrait(?), ca. 1875
Albumen carte de visite, 4″ x 2½″

The Cabinet Card

A larger version of the carte de visite, the cabinet card also enjoyed widespread circulation in the late 19th century.

Baker and Johnson (active Colorado, late 19th century)
Western Town, ca. 1888
Albumen cabinet card, 4¼″ x 6½″

Stone and Needles (active ca. 1880)
A Man with Gun and Camera, ca. 1880
Albumen cabinet card, 5⅜″ x 3¾″

Whittemore (active Salem, Massachusetts, late 19th century)
G. W. Younge, ca. 1890
Albumen cabinet card, 6½″ x 4½″

Western Street Scene, ca. 1888
Albumen cabinet card, 4¼″ x 6½″

The Tintype or Ferrotype, 1850-1900s

Indestructible and cheap, the tintype enjoyed the longest life of any of the collodion-based photographs. Few patient ladies-in-waiting were without at least one tintype of their dauntless uniformed sweethearts who went off to battle during the War Between the States. Forty years later, itinerant street vendors brought the tintype into this cen-

American Family, ca. 1890. This tintype shows 13 family members, spanning four generations, proudly posed in front of the homestead with wagons, guns and horses in view.

tury, continuing to profit from the eternal human vanity, setting up at such popular places as Atlantic City or the local county fair.

The ubiquitous tintype was a collodion positive like the ambrotype but could be made quickly and easily "on the spot." A darkly varnished iron plate rather than glass carried the sensitized collodion. An acceptable and durable image might cost the "while-you-wait" customer an affordable 25 cents. Available in a broad variety of sizes, tintypes enriched the lives and memories of millions.

A. G. Metzger (dates unknown)
Studio Interior, ca. 1890
Tintype, 5″ x 3½″
The artist's posing chair and crudely painted backdrop.

A. G. Metzger
Portrait of a Man, ca. 1890
Tintype, 6¾″ x 4½″

A. G. Metzger
Undercover Agents, ca. 1890
Tintype, 2⅜″ x 3½″

A. G. Metzger
Uncut Multiple Exposure of a Family, ca. 1890
Tintype, 7″ x 5″
Cameras with multiple lenses could take multiple images of the same pose, a boon to the portrait business.

Henry Wadsworth Longfellow, ca. 1880
Tintype, 13″ x 10″

American Family, ca. 1890
Tintype, 6″ x 7¾″

Young Girl, ca. 1890
Painted tintype, 14″ x 10″

Leander Chase Livery, Benefit Street, Providence, Rhode Island, ca. 1870
Tintype, 7½″ x 5½″

Black Man, ca. 1880
Tintype, 2¼″ x 2″
In a geometric composition case.

Button Tintype, ca. 1913
Tintype, diameter 1½″

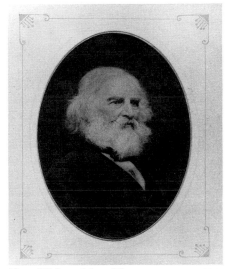

Henry Wadsworth Longfellow, tintype, ca. 1880.

The Ambrotype, 1854-1880s
The ambrotype was a collodion positive made by bleaching a collodion negative and backing it with dark velvet or black varnish. It became the poor man's daguerreotype. Ambrotypes were much less expensive than daguerreotypes, but because they were displayed in daguerreotype cases they were sometimes confused at a casual glance. To distinguish them, one looks for the characteristic mirror effect of the daguerreotype at certain angles. The ambrotype enjoyed substantial popularity until 1865 when the carte de visite caused its relative decline.

The Screamer, ca. 1862
Ambrotype of a painting, 4″ x 5″
The 1861 schooner *Screamer* was built in Bath, Maine. The image is accompanied by several letters to and from the ship's captain.

Railroad Pump Men, ca. 1860
Ambrotype, 2¾″ x 2¼″
Three men posed on top of a railway hand-pump car.

American Family, ca. 1868
Ambrotype, 2½″ x 3⅜″

Portrait of a Man, ca. 1860
Ambrotype with hand-embroidered mat
4¾″ x 3¼″, overall 9¾″ x 7¾″

Mathew B. Brady, *Young Lady*, ca. 1858. A premier daguerreotypist and a master of the collodion process, Brady also made some very fine ambrotypes such as this.

Miscellaneous

Portrait of a Woman, ca. 1900
Crystoleum, 16½″ x 12¾″
Crystoleums are photographs colored to give the appearance of direct paintings upon glass. The system of coloring is about two centuries old. Before the days of photography, engravings and prints were used as a base. The advent of photographic prints on paper did much to revive the interest in coloring processes. A modern crystoleum print properly finished looks like a painting on glass, but actually a transparent photograph lies between the coloring and the glass.

Little Girl with Flowers, ca. 1910
Tinted ivorytype, 16″ x 13¼″
A hand-colored, carbon-transfer print of a young girl on opal glass.

APPARATUS

American Optical Company, New York, New York
Half-Plate Ambrotype Camera, ca. 1868
Wood and brass, 12¼″ x 12⅜″ x 19½″
Bellows-style wet-plate camera for taking ambrotypes half-plate size or smaller, equipped with C. C. Harrison lens #9033. The American Optical Company was a major manufacturer of photographic apparatus during the first three decades of photography. In 1867 the company was acquired by the Scovill Manufacturing Company, which in turn merged with the Anthony Company forming Ansco in 1902.

Tripod, ca. 1860
Wood, 33″ x 21″

Mammoth Wet-Plate Camera, ca. 1860
Wood and brass, 21″ x 18½″ x 33″
This large sliding-box camera for wet-plate negatives was the type used during the Civil War by Mathew Brady's photographic teams. The 10½″ x 13½″ negatives yielded exquisitely detailed prints.

Carte de Visite and Tintype Album, ca. 1880; *Carte de Visite Backs,* ca. 1865; *Carte de Visite Standing Frame,* ca. 1885; *Carte de Visite and Tintype Album,* ca. 1870.

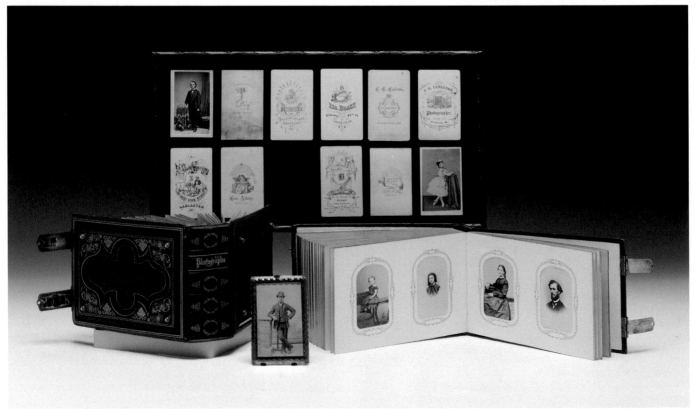

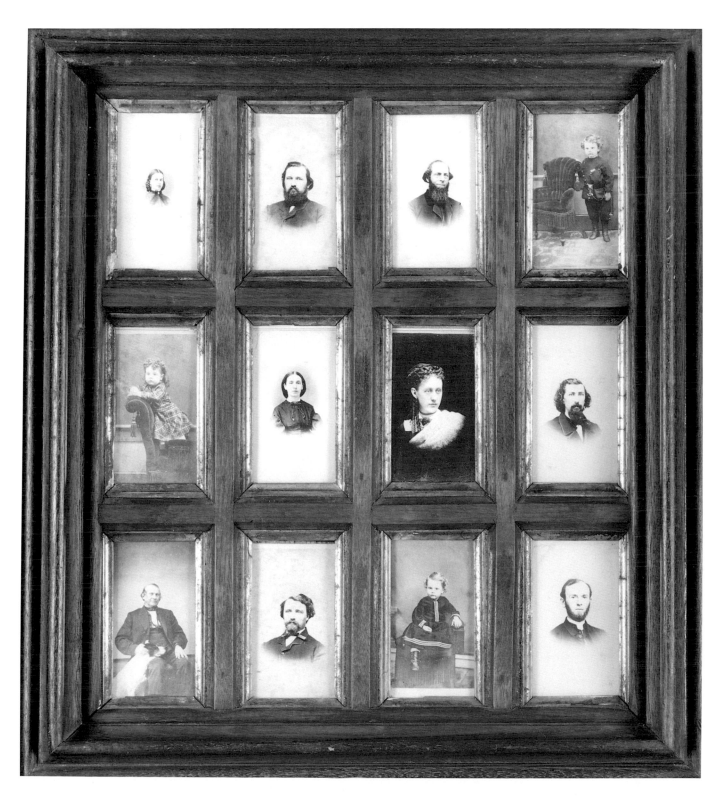

Wall Frame with 12 Cartes de Visite, ca. 1870.
This multi-image frame was specially made for the carte de visite.

Mammoth Wet-Plate Printing Frame, ca. 1860
Wood and glass, 3½″ x 21½″ x 25½″
It is difficult to imagine the size of the camera necessary to hold the glass plate that was printed on this frame and even more imponderable to think of hauling such a camera about!

International Metal and Ferrotype Company, Chicago, Illinois
The Diamond Gun Tintype Camera, ca. 1913
Nickel and glass, 16″ x 8″ x 21″
This large, formidable cannon-shaped nickel camera certainly would catch the eye of someone wanting a picture made.

Tintype Camera, ca. 1900
Wood, 13″ x 11″ x 15″
A hand-crafted camera for taking tintypes.

Tripod, ca. 1900
Wood and metal, 57½″ x 4″

The Popular Photograph Company, New York, New York
Nodark Tintype Camera, ca. 1899
Wood and nickel, 4½″ x 3½″ x 12½″
This wooden box camera with ornate nickel hardware took 26 exposures on dry ferrotype plates. An intricate mechanism advanced the plate after its exposure and dropped it into a developing tank beneath the camera. "No darkness" was necessary, thus the camera name Nodark. Kodak Company won a trademark infringement suit in Europe because of the similarity between the words Kodak and Nodark.

Dipping Tank, ca. 1865
Wood and glass, 12″ x 11″ x 10½″
These tanks contained the silver bath used to immerse the collodion coated glass plate before it was inserted in the camera plate-holder.

Scale, ca. 1865
Brass, 8½″ x 11″ x 3¾″
Weighing and mixing chemicals was all part of the production process when early photographers made pictures with the wet-plate technique.

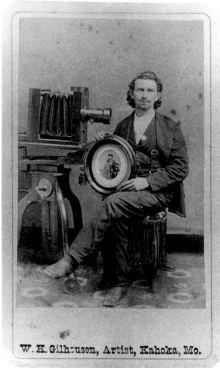

W. H. Gilhousen, Artist, Kahoka, Mo.

William H. Gilhousen, *Self Portrait(?)*, albumen carte de visite, ca. 1875.
The back of this card reads:
> A situation desired as colorist in India ink watercolors or oil especially the latter. Also as a thorough practician in copying enlarging and solo printing. Will furnish my own Solar Camera goin to some gallery and share profits or work for reasonable wages. Object – a change of climate.
> Wm H. Gilhousen Kahoka Mo.

J. H. Beal, *Watson Catlin Drugstore, New York*, albumen print, ca. 1870. "Dealers in drugs, medicine, paints, oils, brush, dyestuff and chemicals," this drugstore clearly sold it all.

Powers-Weightman-Rosengarten Company, Philadelphia, Pennsylvania
Jar of Ferric Hyposulfite, ca. 1865
Glass, 6¼″ x 2½″
Square Jar, ca. 1865
Glass, 4½″ x 2½″ x 2½″
Square Jar, ca. 1865
Glass, 4″ x 1⅞″ x 1⅞″

E. and H. T. Anthony and Company, New York, New York
Anthony's Negative Guncotton, ca. 1865
Paper box, 3″ x 2⅝″ x 2⅝″
Collodion Bottle, ca. 1865
Glass, 9″ x 3″
Note the special spout for the even pouring of the collodion over the glass plate and the specially designed bottle top to prevent evaporation.
Plate Rack, ca. 1860
Wood, 10″ x 6¼″ x 1″
For holding glass plates.
Four Tube Lens Set, ca. 1870
Wood and brass, 6½″ x 5″ x 9½″

COLLATERAL MATERIAL
Charles Waldack (active ca. 1866)
Peter Neff, Jr. (dates unknown)
Treatise of Photography on Collodion, 1858
Longley Brothers, Cincinnati, Ohio
This early work on collodion explores the chemistry and techniques of the wet-plate with a special focus on the melainotype (tintype). Neff, who had patented the use of japanned metallic plates in photography in 1856, wrote, "Compare the labor of producing daguerreotype and glass pictures, with the simplicity of the melainotype (the plate for which requires no cleaning or preparation) and the exhausted operator will at once drop his silver tormentor, never to be resumed."

Edward M. Estabrooke (dates unknown)
The Ferrotype and How to Make It, 1880
E. and H. T. Anthony and Company, New York
An instructional book for "aiding and improving the production of the beautiful and enduring Ferrotype." An original ferrotype (tintype) is mounted inside the cover.

P. McAdams, American (active 1860s)
The Ambrotypists, ca. 1864
Albumen print, 5¼″ x 7¾″

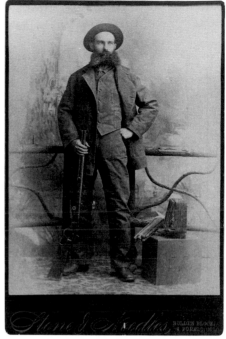

Stone and Needles, *A Man with Gun and Camera*, albumen cabinet card, ca. 1880. The exploration of the western frontier saw the use of gun and camera as depicted in this studio portrait.

P. McAdams, albumen print, *The Ambro-typists*, ca. 1864. Two photographers in front of their ambrotype tent. Handwritten on the reverse: "View from the North of Clouds Mill, Virginia, the scene of numerous skirmishes between the Union troops and the Rebels during the War of the Rebellion."

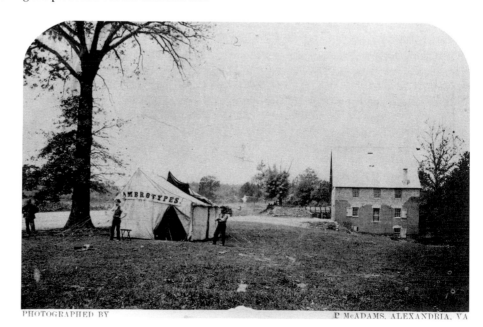

PHOTOGRAPHED BY P. McADAMS, ALEXANDRIA, VA.

The Tintypist, ca. 1900
Albumen print, 4¼″ x 6¼″
The proud photographer stands in front of his Victorian gingerbread studio with examples of his work.

Three Men with Tintype Camera, ca. early 1900s
Gelatin-silver print, 3¾″ x 3″

Wall Frame with 12 Cartes de Visite, ca. 1870
Wood and glass, overall 12″ x 16″

Carte de Visite Standing Frame, ca. 1885
Brass and glass, 4½″ x 2⅞″
A small frame for a single carte de visite.

Carte de Visite and Tintype Album, ca. 1870
Leather and paper, 6″ x 9″ x 2″
A wide variety of finely tooled and ornate albums were made to house the family portrait gallery.

Carte de Visite and Tintype Album, ca. 1880
Leather and paper, 6″ x 8½″ x 2½″

Gem Fairy Album, ca. 1880
Leather and paper, 1⅞″ x 1⅝″ x 1″
For holding miniature tintypes, often called gems, this album is titled "Fairy Tales."

Gem Tintype Album, ca. 1880
Leather and paper, 3¾″ x 4¾″ x 1″

Carte de Visite Backs, ca. 1865
Overall 9¾″ x 18¾″
Photographers often would advertise on the back of the carte de visite. Many such logos pictured a camera or intricate design and elaborate calligraphy.

Montage of Gem Tintypes and Advertisements, ca. 1870
Tintypes and ink on paper, 8¼″ x 9⅛″

G. C. Poor (dates unknown)
Well! Well! Well!, ca. 1900
Broadside, ink on paper, 18¾″ x 11¾″
G. C. Poor, photographer from Brownfield, Maine, touted that if you bought 50 cents worth of tintypes, you would get a crayon portrait free.

Leander Cook (dates unknown)
Pictures! Pictures!, ca. 1880
Broadside, ink on paper, 11½″ x 7½″
With his traveling saloon, Cook would be in town only a few days, and this typical advertisement insists "children must come around noon for the best light."

Photographic Sculpture, ca. 1976
Ceramic, 9½″ x 6½″ x 4″
This Lionstone porcelain whiskey bottle of a photographer commemorates William Henry Jackson, the "Father of Yellowstone National Park."

Wet-Plate Photographer, ca. 1870
Cast bronze, 9½″ x 5″
This statuette may have derived from the work of Honoré Daumier (1808-1879), a prolific caricaturist, sculptor and lithographer. The photographer peering through the rear of the camera has the face of the devil – a point of view held by some who saw photography as a sacrilegious enterprise, for God alone was allowed to recreate nature with such exactitude. It is just as likely that it simply represented the evil side of all who hunt the world from behind a lens. A profile of this statue became the logo of Anthony's *Photographic Bulletin* in 1870.

Stannard and Son (dates unknown)
Gay Photographer, ca. 1890
Lithograph, 13½″ x 9½″
"The Gay Photographer" was a popular song by George Grossmith, Jr.

MATHEW BRADY, ABRAHAM LINCOLN AND THE CIVIL WAR

MATHEW B. BRADY

The most famous name in the history of American photography is Mathew Brady (American 1822-1896). A miniature casemaker when he became a pupil of Samuel Morse in 1840-1841, Brady opened a daguerreian gallery in New York in 1844, launching a photographic career of unequaled prestige, glamour and adventure. He successfully sought to photograph most of the notables of the day and in doing so, established an international reputation. Even Abraham Lincoln was indebted to Brady, stating that "Brady's camera…put me in the White House."

Isabella Bird Silver Chalmers (dates unknown)
Portrait of a Man said to be Mathew B. Brady, date unknown
Oil on canvas, 16″ x 13″
With his graying goatee Brady looks to be about 45 years old.

Mathew B. Brady
Young Lady, ca. 1858
Ambrotype, 7″ x 5¾″

Mathew B. Brady
Portrait of a Woman, ca. 1840s
Tinted daguerreotype, 2¾″ x 2¼″
A typical daguerreian portrait with pad marked "Brady Gallery/205-359 Broadway, New York."

Mathew B. Brady
Daguerreotype Case, ca. 1840
Wood and leather, 3¾″ x 3¼″
An early daguerreian case marked "M. B. Brady – Case Maker".

Mathew Brady Signature, ca. 1860
Pencil on paper, 1½″ x 2¾″
Brady had no formal schooling and it is questionable whether he could read or write. There is evidence that he was able to read, but it is probable that his writing ability was virtually non-existent. This signature represents one of the few signed pieces known. No letters written by him are extant.

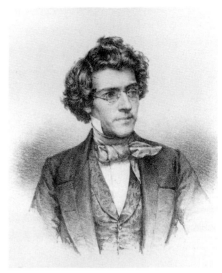

This engraving of Mathew Brady appeared on the inside cover of *The Photographic Art Journal,* volume 1, 1851.

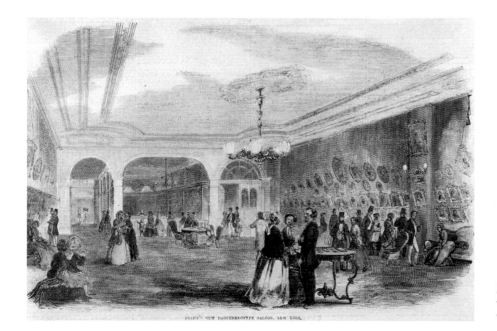

BRADY'S NEW DAGUERREOTYPE SALOON, NEW YORK.

Brady's New Daguerreotype Saloon, New York, woodcut, ca. 1840s. The spacious and lavish waiting room of Brady's Broadway Gallery.

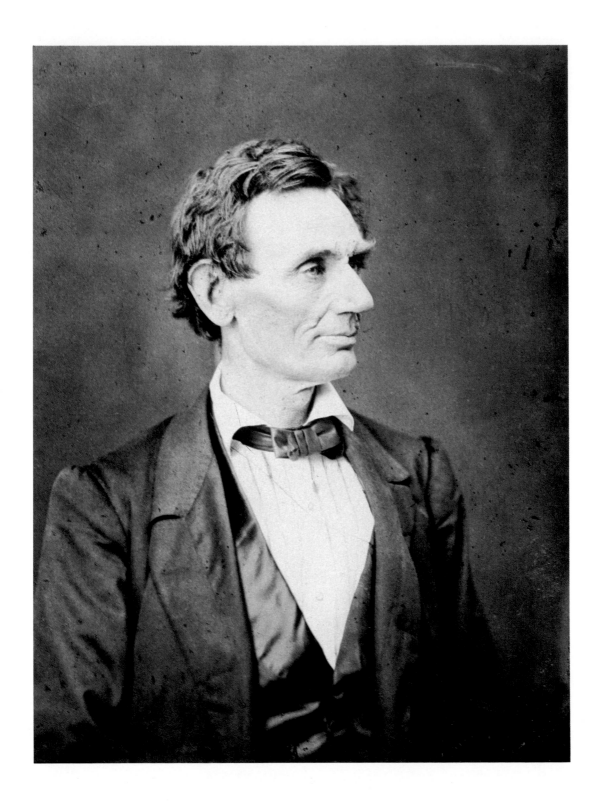

The Photographic Art Journal, volume 1, 1851
H. H. Snelling, New York
This first issue appeared during a high point in Brady's career when the daguerreotype flourished. An engraving of Brady by artist Francis D. D'Aignon graces the inside cover and is followed by a complimentary article.

Brady's New Daguerreotype Saloon, New York, ca. 1840s
Woodcut, 6½" x 9½"

Mathew B. Brady
Broadside for Brady's Daguerreian Galleries, ca. 1840s
Ink on paper, 8½" x 5½"

ABRAHAM LINCOLN

Norman Rockwell, American (1894-1978)
Brady and Lincoln, 1975
Lithograph, 19¼" x 35¼"
Lincoln liked being photographed and is pictured in Brady's gallery looking cooperatively at the camera while Brady times the exposure.

Mathew B. Brady
Lincoln Memorial Portrait Engraving, February 9, 1864
Tintype of an engraving, 3⅛" x 2⅛"
There is evidence that this famous portrait may have been taken by Anthony Berger, the manager of Brady's Washington Gallery. It was taken on February 9, 1864, and is the portrait found on our $5 bill. It is framed in black and is said to be a posthumous commemorative memorializing Lincoln.

Alexander Hesler, American (1823-1895)
George Ayres, American (dates unknown)
Abraham Lincoln, negative by Hesler 1860, print by Ayres ca. 1881
Platinum print, 8" x 6"

William Marsh or William Church (dates unknown)
Portrait of Lincoln, May 20, 1860
Albumen print, 7" x 5"
This was taken in the north parlor of Lincoln's Springfield home the evening before he received the Republican nomination for the presidency.

THE CIVIL WAR

Mathew B. Brady
Abraham Lincoln, 1865
Albumen print, 3" x 2"

Mathew B. Brady
Jefferson Davis, 1860
Albumen print, 3" x 2"

Mathew B. Brady
Yorktown, Virginia, 1862
Albumen print, 8½" x 6½"

Y. H. Young, American, b. 1832 (active Baltimore, Maryland 1860s)
Civil War Soldier, ca. 1860s
Salt print, 7¼" x 5¼"

Left: Alexander Hesler and George Ayres, *Abraham Lincoln,* platinum print, ca. 1881. This was taken at Lincoln's home in Springfield, Illinois, immediately after his nomination for the presidency. Ayres purchased the negative from Hesler and made several prints. In 1933 the glass plates were irreparably damaged.

Right: Mathew B. Brady, albumen print, *Abraham Lincoln,* 1865. This carte de visite was taken about the time of the fall of Richmond in 1865, just a few days before Lincoln went to view the ruins of the capital of the Confederacy.

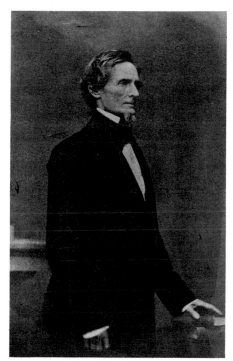

Mathew B. Brady, albumen print, *Jefferson Davis,* 1860. Davis served the U. S. with distinction during the Mexican War, was a member of the Senate and House of Representatives and secretary of war in the Franklin Pierce administration. In 1861, he was elected president of the Confederate States of America.

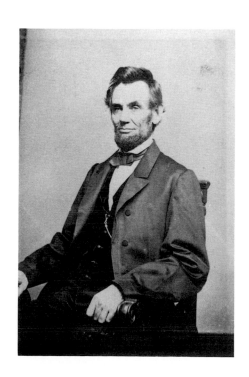

George N. Barnard, American (1819-1902)
Barnard at Federal Fortification at Atlanta, 1864
Albumen print, 9½" x 13"
A photograph showing George Barnard's Civil War photographic team in the field along rebel lines southeast of Atlanta. The dark tent in the foreground was used for developing wet-plates. Barnard was a fine photographer who assisted Brady early in the war and joined Alexander Gardner (1821-1882) in 1863. He is most noted for his photographs of Sherman's Southern Campaign.

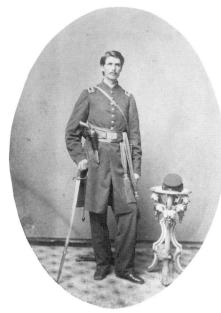

Y. H. Young, salt print, *Civil War Soldier,* ca. 1860s.

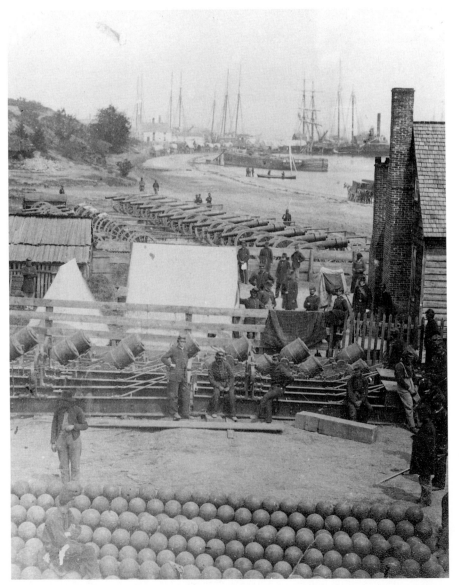

Mathew B. Brady, albumen print, *Yorktown, Virginia,* 1862. One of the finest pictures composed by Brady shows Union preparations for the unsuccessful Peninsula Campaign of 1862. General McClellan brought his artillery to Yorktown before proceeding up the York River to Richmond. Brady and his dark tent appear in the background of this image.

POPULAR ENTERTAINMENT

NIAGARA FALLS 1855-1920

The natural wonder, Niagara Falls, has been photographed using every technique developed since the days of the daguerreotype.

Platt D. Babbitt, American (active 1850s-1870s)
Niagara Falls, ca. 1855
Daguerreotype, 3½" x 4¾"
According to Beaumont Newhall in *The Daguerreotype in America*:

> . . . [Babbitt] set up an outdoor studio with the nation's most popular tourist attraction as a background. By arrangement with the manager of the American side of the falls, he set up a daguerreotype camera on a permanent tripod, pointing straight at the Horseshoe Falls across Prospect Point. Above the camera he built a hip-roofed pavilion as much to advertise his presence as to protect his equipment from the elements. When visitors stood on the brink of Prospect Point to admire the falls, he took their pictures. Dozens of daguerreotypes exist, all identical except for the people. Babbitt continued at his stand from 1854 well into the last quarter of the century, making group photographs in all the techniques which followed the daguerreotype.

Platt D. Babbitt (attributed)
A Honeymoon Couple, Niagara Falls, ca. 1860
Ambrotype, 5⅛" x 7¼"

George Barker, American (active 1860s-1870s)
At the Cave of the Winds, Niagara Falls, New York, ca. 1870s
Albumen stereograph, 3½" x 7"

George Barker
Railway Suspension Bridge, Niagara Falls, ca. 1870s
Albumen stereograph, 4¼" x 7"

Charles Bierstadt, American (active 1860s-1890s)
Cave of the Winds House, Winter, Niagara Falls, ca. 1873-1890
Albumen stereograph, 4¼" x 7"

George E. Curtis, American (active 1870s)
Crystal Grotto, Niagara Falls, ca. 1870s
Albumen stereograph, 3½" x 7"

William Langenheim, American, b. Germany (1807-1874)
Frederick Langenheim, American, b. Germany (1809-1879)
Terrapin Tower from Goat Island, Niagara Falls, 1850
Glass stereograph, 3¼" x 6¾"

Richard Walzl, American, b. Austria (1843-1899)
Niagara Falls, ca. 1875
Albumen print, 10¼" x 19"
Mammoth print of American Falls and Horseshoe Falls from the suspension bridge.

Outdoor Group, Niagara Falls, ca. 1900
Tintype, 4⅝" x 6¾"
A group clad in oilskin garb stands in front of the American Falls. Outdoor tintypes of Niagara are quite rare, perhaps because of the rust created on the iron plates by the moisture from the falls.

Automobile, Niagara Falls, ca. 1920
Tintype, 3¼" x 4½"

Two Men, Niagara Falls, ca. 1880
Tintype, 3½" x 2⅜"
The painted studio background in this image could be confused with an outdoor scene.

Underwood and Underwood, Ltd., publishers
Ice Clad Precipice and American Falls, Niagara, ca. 1903
Gelatin-silver stereograph, 3½″ x 7″

Underwood and Underwood, Ltd., publishers
General View of the Falls, 1903
Gelatin-silver stereograph, 3½″ x 7″

View of Terrapin Tower, Niagara Falls, late 1860s
Albumen print, 7⅛″ x 9¼″
Terrapin Tower was built in 1833 and destroyed in 1873.

The Falls in Winter, ca. 1920
Glass transparency, 8¼″ x 10¼″

Niagara Falls, clockwise from top left: Richard Walzl, albumen print, ca. 1875; Unknown artist, *The Falls in Winter,* glass transparency, ca. 1920; Unknown artist, *View of Terrapin Tower,* albumen print, late 1860s; Langenheim Brothers, *Terrapin Tower from Goat Island,* glass stereograph, 1850; George Barker, *At the Cave of the Winds,* albumen stereograph, ca. 1870s; Unknown artist, *Automobile,* tintype, ca. 1920; Platt D. Babbitt (attributed), *A Honeymoon Couple,* ambrotype, ca. 1860; Unknown artist, *Two Men,* tintype, ca. 1880; Unknown artist, *Outdoor Group,* tintype, ca. 1900; Platt D. Babbitt, daguerreotype, ca. 1855.

STEREOSCOPY – THE ILLUSION OF DEPTH

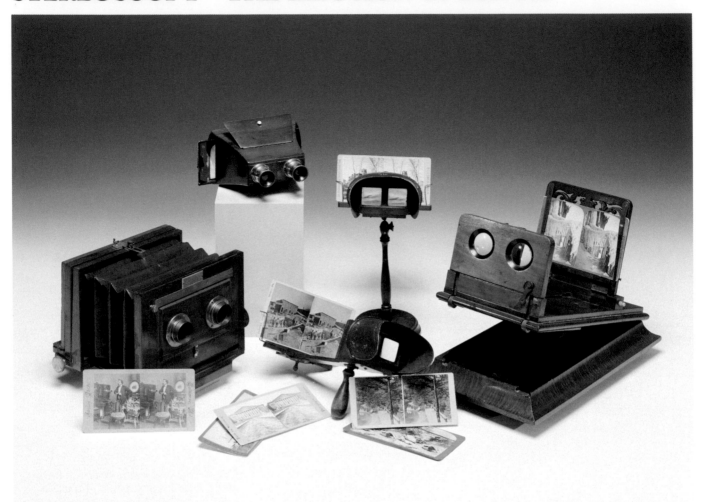

From left: American Optical Company, *Dry Plate Stereo Camera*, ca. 1880; *Brewster-Style Hand-Held Stereo Viewer*, ca. 1855; *Holmes-Style Hand-Held Stereo Viewer*, ca. 1870; *Holmes-Style Pedestal Stereo Viewer*, ca 1890; *Anthony Graphoscope*, ca. 1875.

The phenomenon of depth perception was recognized in 1833 by the Englishman Sir Charles Wheatstone (1802-1875). He explained how we visually discern perspective and relief, pinning down the textural nature and location of an object by actually observing it from two points of view – each eye recording a slightly different version of the same object. The versions are fused into one by the brain, which interprets their relative differences in terms of depth and relief. Sir David Brewster (1781-1868) envisioned this principle being applied to photography. He reasoned that if two photographs are taken of a subject from two slightly different points of view, one photograph presented to one eye and the other photograph to the other eye, and one eye cannot see what the other is seeing that the illusion of depth will be produced. Wheatstone constructed an instrument for this purpose in 1838, which he called the stereoscope. Brewster was the first to successfully design a box stereoscopic viewer in 1849.

It wasn't until a London exhibition in 1851 that stereo photography gained popularity, for it had touched the sensibilities of none other than Queen Victoria who proclaimed it a success. Antoine François Claudet (1797-1867), a student of Daguerre and a distinguished French daguerreotypist living in England, was one of the first to apply daguerreotypy to the stereoscope. However, it was the arrival of the collodion wet-plate and the easy production of multiple prints that allowed stereo photography to blossom into maturity.

STEREO PHOTOGRAPHY

In the early days of stereo photography, two images were taken using side-by-side cameras. Soon, stereoscopic cameras were introduced. These view-type cameras were equipped with two lenses 2½" apart (the distance separating the eyes) and a square bellows bisected with a septum. The stereo negative was approximately 3½" by 7 inches. The resulting prints were separated and mounted on cardboard.

The Langenheim Brothers of Philadelphia brought stereo to this country in 1854, and stereo companies soon began to appear in America and abroad. Various designs for hand and table viewers emerged, and the stereo grew in popularity. The writer Oliver Wendell Holmes (1809-1894) introduced a simple, inexpensive stereo viewer in 1859: a hooded pair of lenses with a convenient hand grasp and adjustable card holder.

From 1850 to 1930 thousands of professional photographers indulged in the making of stereo viewers, with millions of stereographs being made in this country alone. The stereoscope was a form of entertainment as pervasive as today's television.

IMAGERY

Antoine François Claudet, French (1797-1867)
Portrait of a Woman, ca. 1855
Tinted daguerreotype stereograph, 3¼" x 7"
Back label reads: "Under The Patronage of Her Majesty/By Royal Letters Patent/Mr. Antoine Claudet/107 Regent Street/Daguerreotype Miniatures/Plain and Coloured Stereoscopic Daguerreotype Portraits"

D. A. Clifford, American (active 1870s)
St. Johnsbury Anthenaeum, ca. 1868
Albumen stereograph, 3½" x 7"

Kilburn Brothers, American (active 1860s-1870s)
Profile Lake, Franconia Notch, ca. 1865-1870
Albumen stereograph, 3½" x 7"

William Langenheim, American, b. Germany (1807-1874)
Frederick Langenheim, American, b. Germany (1809-1879)
Starruca Viaduct, ca. 1854
Talbotype stereograph, 3¼" x 6¾"
An example of the first American commercial paper stereograph. The copyright line reads: "Entered according to Act of Congress in the year 1854, in the clerk's office the district court for the Eastern District of Pennsylvania."

John E. McClees (active Philadelphia, 1850s-1860s)
Portrait of a Man, ca. 1855
Daguerreotype stereograph in Mascher case, 2½" x 3¾"
In 1853 J. F. Mascher of Philadelphia patented this stereo daguerreotype case with viewing lenses in the lid.

Nude, ca. 1855, tinted daguerreotype stereograph.

Rippel Brothers, American (active 1870s)
Flood, ca. 1870
Albumen stereograph, 4″ x 7″

V. E. Schuler, German (active 1860s-1870s)
Thuringen – Jena and Umgegend, ca. 1860-1870
Tinted albumen stereograph, 3½″ x 7″

William F. Shorey, American (1833-?)
Shorey, Photographer, Baltimore, Maryland, ca. 1875
Albumen stereograph, 4″ x 7″

Underwood and Underwood, Ltd., publishers
When the Frost is on the Pumpkins, 1904
Gelatin-silver stereograph, 3½″ x 7″

E. and H. T. Anthony Company, publishers
Washington's Headquarters at Newburgh, New York, ca. 1875
Albumen stereograph, 3½″ x 7″

Keystone View Company, publishers
The Queen of Belgium Making a Stereo Photograph, ca. 1920
Gelatin-silver stereograph, 3½″ x 7″

Unknown Artist, probably French
Nude, ca. 1855
Tinted daguerreotype stereograph, 3¼″ x 6¾″

Unknown Artist, probably French
Nude, ca. 1885
Gelatin-silver stereograph, 3½″ x 7″

APPARATUS

Franke and Heidecke, Braunschweig, Germany
Heidoscope Stereo Camera, ca. 1930
Metal and leather, 6″ x 7″ x 4½″
A German reflex stereo camera for plates or cut film.

Contessa-Nettel, Stuttgart, Germany
Stereo Camera, ca. 1921
Metal, 4″ x 5¼″ x 2¾″
A stereo camera for cut film with Tessar lenses and Compur shutter.

American Optical Company, Scovill Manufacturing Company, New York, New York
Dry Plate Stereo Camera, ca. 1880
Wood and brass, 8″ x 9⅜″ x 11½″
An early dry plate stereo camera.

Dry Plate Stereo Negative, ca. 1890s
Glass, 4½″ x 7½″

Holmes-Style Hand-Held Stereo Viewer, ca. 1870
Wood, 6½″ x 7½″ x 13″

Holmes-Style Pedestal Stereo Viewer, ca. 1890
Wood, 13″ x 7″ x 13″

Alexander Beckers, American, b. Germany (active New York 1840s-1870s)
Table Top Stereo Viewer, ca. 1865
Wood, 18″ x 10″ x 11″
This two-sided "sweetheart" viewer contains more than 100 early flat-mount foreign and American views by W. England, J. P. Soule, E. and H. T. Anthony, C. Watkins and others. Beckers was an accomplished daguerreotypist as well as inventor of photographic viewing devices. The original Beckers viewer patent was issued in 1858.

Sir David Brewster, English (1781-1868)
Brewster-Style Hand-Held Stereo Viewer, ca. 1855
Mahogany and brass, 4″ x 6¼″ x 7″

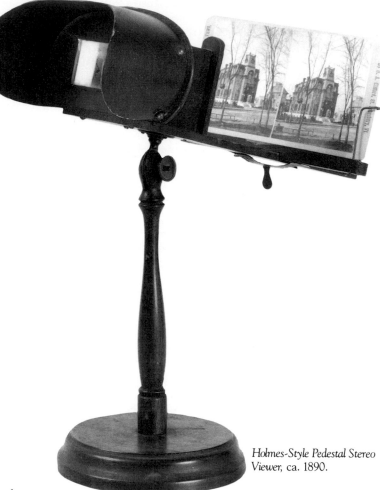

Holmes-Style Pedestal Stereo Viewer, ca. 1890.

Sir David Brewster
Brewster-Style Hand-Held Stereo Viewer, ca. 1855
Rosewood, 4″ x 6¾″ x 7″
These viewers were designed to view either stereo daguerreotypes or stereo glass plates.

E. and H. T. Anthony and Company, New York, New York
Anthony Graphoscope, ca. 1875
Wood, 10″ x 10″ x 16″
A curly maple combination stereo and monocular viewer. In 1871, Anthony announced the introduction of the graphoscope priced $28 to $55. It was reported that "photographers are awakening to the fact that one of these instruments, placed on the table of their reception and show rooms, forms a feature of much attraction." Graphoscopes allowed viewing stereographs through a normal twin lens and magnified other photographs with a large, powerful single lens.

COLLATERAL MATERIAL

Julius M. Wendt, American (active 1900s-1910s)
Illustration of Poco Stereo Camera on Back of Stereograph, ca. 1910
Gelatin-silver stereograph, 3½″ x 7″

Illustration of Holmes Stereo Viewer on Back of Stereograph, ca.1866
Albumen stereograph, ca. 1866, 3½″ x 7″

J. C. Brown (dates unknown)
A Pleasing Subject, 1891
Lithograph, 22½″ x 15¾″
A young lady views a stereograph. A viewer and a basket of cards graced the parlor of most households of that period.

J. A. Tennant, editor (dates unknown)
The Photo Miniature
Dawbarn and Ward Ltd., London, volume I, no. 5, August 1899
A special issue on stereoscopic photography.

Shorey, Photographer, Baltimore, Maryland, ca. 1875, albumen stereograph. William F. Shorey had a successful career in photography with numerous galleries in Baltimore. He is pictured here standing beside a studio camera and other items of the trade.

NOVELTY AND PREMIUM PHOTOGRAPHY

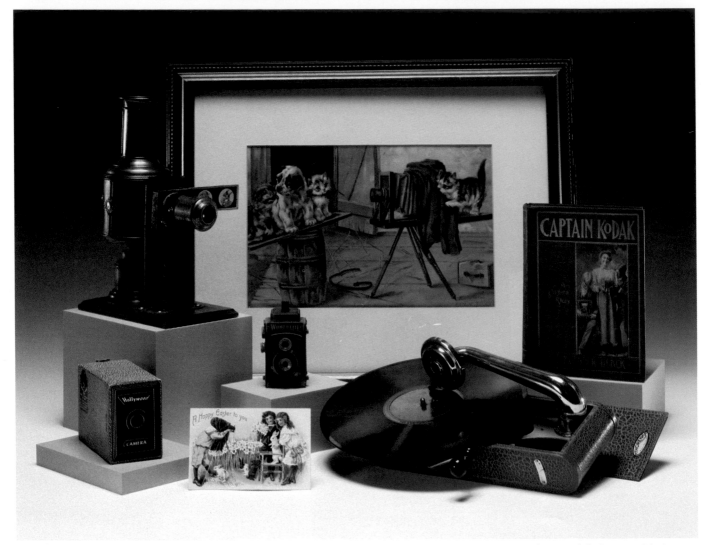

Clockwise from top left: *Lanterna Magica*, 1890; *Cat Photography*, ca. 1920; *Captain Kodak – A Camera Story*, 1899; *Thorens Cameraphone*, ca. 1947; *Wond-O-Lite*, ca. 1950; *Photo Postcard*, ca. 1900; *Hollywood Camera*, ca. 1950.

M. K. Dunne (dates unknown)
Dunne's Correspondence Course of Photograph Coloring, 1906
National Photo and Lantern Slide Color Company, New York

M. K. Dunne
Dunne's Photograph Coloring Kit, 1906
1⅞″ x 9¾″ x 5″

Grand Canyon, early 1900s
Hand-colored gelatin-silver print, 18″ x 13¾″

C. L. Van Vredenburgh (dates unknown)
Cat Photography, ca. 1920
Lithograph, 8¾″ x 13½″
A comical piece of animal photographica.

Perry Mason and Company, Boston, Massachusetts
The Harvard Snap-Shot Camera Kit, ca. 1890
Metal, 4″ x 6″ x 8″
This camera was offered as one of the many premiums for selling subscriptions to *The Youth's Companion*.

The Youth's Companion, January 1 – December 29, 1892
Perry Mason and Company
The Sure-Shot, 1897
Wood, 3″ x 4″ x 3″
This diminutive wooden glass plate camera may well have been offered as a premium.

Expo Camera Company, New York
The Expo, ca. 1910
Metal, diameter 2¾″

Expo Camera Company, New York
Expo Enlarger, ca. 1910
Wood, 3¾″ x 3″ x 5¾″

Alfred C. Kemper, Chicago, Illinois
The Kombi, ca. 1894
Metal, 2″ x 2″ x 2″
This seamless metal miniature box camera with oxidized silver finish took 1⅛-inch,
25-exposure roll film. It doubled as a transparency viewer, thus the name Kombi.
Reportedly 50,000 sold in one year for $3 each.

Wond-O-Lite, ca. 1950
Metal, 3¾″ x 2¼″ x 2″
Lighter and cigarette case designed to look like twin-lens reflex camera.

Encore Camera Company, Hollywood, California
Hollywood Camera, ca. 1950
Paper, 3⅝″ x 2½″ x 5¼″
A cardboard novelty camera purchased loaded with film. After exposure, the user
would return the camera and for $1 receive his developed prints, reminiscent of
the early Kodak.

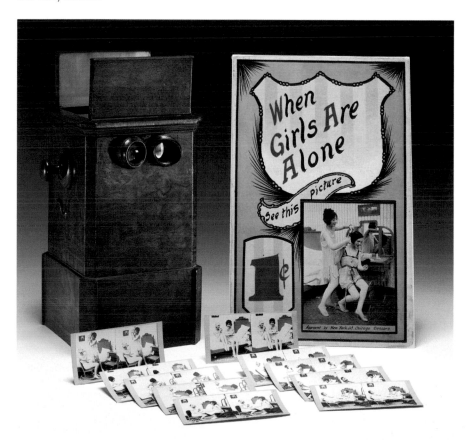

When Girls are Alone, 1925. This penny arcade broadside invites the viewer to see "When Girls are Alone" for one cent. The image on the advertisement represents one of 15 stereographs that made up the series. It is clearly marked "Approved by the New York and Chicago Censors." On the left is the Beckers *Table Top Stereo Viewer,* ca. 1865.

Thorens, Switzerland
Thorens Cameraphone, ca. 1947
Metal, 2″ x 11″ x 4¾″
Phonograph in shape of a camera.

Five Photo Postcards, ca. 1900
Paper, each approximately 5½″ x 3½″
A gathering of colored lithographic postcards each featuring a photographic theme.

Russ Westover (dates unknown)
Snapshot Bill, New York Herald, May 3, 1914
Comic strip, 16″ x 21½″
A comical look at the rigors of photographing a child.

When Girls are Alone, 1925
Ink on paper, tinted gelatin-silver photograph, 22″ x 14″

When Girls are Alone, 1925
Fifteen gelatin-silver stereographs, 3¼″ x 6¼″

Chicago Ferrotype Company, Chicago, Illinois
Mandelette, 1914
Lithograph, 4¼″ x 9¼″
Advertisement for the Mandelette postcard camera. The "greatest sensation in the picture-making world." This "wonderful picture machine gives you a finished postcard picture in one minute." A popular camera, it sold for $5.50.

A. H. Baird (dates unknown)
Magic Lantern Projector, ca. 1890
Wood, brass and tin, 18½″ x 13″ x 21¾″

Lanterna Magica, Germany, 1890
Wood and tin, 11″ x 8″ x 4¾″
An example of a child's toy version of the magic lantern with hand-painted glass slides. Illumination was with an oil lamp.

C. T. Milligan (dates unknown)
Broadside – Dissolving Views, ca. 1890
Ink on paper, 24″ x 9¼″
Advertising for a magic lantern show featuring:

> "Lloyd's Round Trip over land and sea . . . A splendid intellectual and amusing entertainment for old and young, something to think on with delight and talk about with profit. Visions of grandeur and beauty to be remembered for a lifetime. For 40 cents – dissolving views on 30 foot screen!"

Magic Lantern Projector, ca. 1890. The magic lantern projected transparencies (lantern slides) by artificial light (incandescent gas) upon a screen. This example was made by A. H. Baird, "scientific instrument maker," Edinburgh.

PANORAMIC PHOTOGRAPHY

Roll film saw the revival of the panoramic camera. In 1845, Friedrich Von Martens took panoramic views using a daguerreotype camera containing a lens that swung through a horizontal arc of almost 180 degrees. Panoramic views were impractical, however, until the advent of a flexible roll film.

Multiscope and Film Company, Burlington, Wisconsin
Al-Vista Panoramic Camera, ca. 1898
Leather and wood, 6¼″ x 13¼″ x 7½″
The Al-Vista Panoramic accomplished the feat of photographing, in a single exposure, a scope of about 180 degrees. "The traveling lens does it" was the cry of the advertisers.

Winslow Studio
Big Freeze, Vinalhaven, February 1918
Panoramic gelatin-silver print, 3⅝″ x 13½″

Al-Vista Panoramic Camera, ca. 1898; *Big Freeze, Vinalhaven*, panoramic gelatin-silver print, February 1918.

PHOTOGRAPHY
FOR EVERYONE

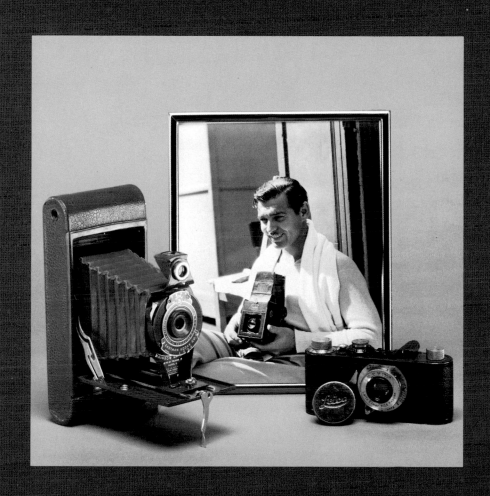

DRY PLATE PERIOD: 1880-1920

For 30 years tired backs and dirty hands longed for liberation from the physical rigors of wet-plate photography. A portable darkroom, glassware, chemicals, camera and tripod all had to be lugged along by the photographer enslaved by a pack-horse load of paraphernalia. Because the efficiency of collodion relied on its being tacky at the time of exposure, honey, sugar, flat beer, raspberry syrup and other less appetizing substances were tried in an attempt to preserve the proper consistency. Fortunately for progress, no effective preservative was ever found. The need for a substance to replace collodion grew.

Around 1870, a physician and amateur photographer named R. L. Maddox (1816-1902) discovered the photographic potential of gelatin, a substance produced from the hides and bones of animals. He added silver nitrate to a solution of cadmium bromide and gelatin, then spread the milky suspension on a glass plate and allowed it to dry. The dry emulsion was still light-sensitive; when cooked its sensitivity greatly exceeded that of wet collodion. In the early days its speed depended on the amount of mustard plant in the animal's diet. Good quality gelatin from a mustard-gorged horse brought exposure times down to a fraction of a second! Eventually, the light sensitivity of silvered gelatin was synthetically controlled.

Edward S. Curtis, *Prayer to the Stars,* ca. 1900. Orotones are positive images on glass with gold leaf backing. *Prayer to the Stars,* made as an illustration for Marah Ellis Ryan's novel *The Flute of the Gods,* shows the devotee reaching out his hands in supplication to his brothers the stars. Curtis spent a large measure of his prolific photographic career capturing the soul of the North American Indian. His unequaled portrait of the vanishing race received the patronage of President Theodore Roosevelt and the financial backing of J. Pierpont Morgan in 1906.

Modern Dry Plates or Emulsion Photography,
1881; The 4″ x 5″ Rochester View Camera and
Darkroom Outfit, ca. 1895.

George Eastman (1854-1932), an upstate New York bank clerk and amateur pho-
tographer, began by making gelatin plates in his mother's kitchen. By 1881, he and an
associate had established the Eastman Dry Plate Company in Rochester, the birthplace
of what became a photographic empire. Now freed from the burden of a portable
darkroom and afforded a much more light-sensitive plate the liberated photographer
didn't even need a tripod. With a hand-held camera, he now had the ability to arrest
motion.

Being able to buy a package of sensitized dry plates attracted a whole new population
of photographic enthusiasts who hitherto had not been willing to put up with the
clumsy impedimenta of wet-plate photography.

THE DRY PLATE CAMERA

During the 1880s, a rash of new camera species evolved as a result of the dry and
speedy gelatin emulsion. Previously the acidic drippings and relative slowness of the
wet-plate dictated the design and construction of cameras. Wet photography not only
tried the patience but rotted the cameras of photographers for 30 years. In choosing a
dry plate camera, the photographer of the 1880s, could now either "stand it" (on a
tripod) or "hand it" (hand-hold the camera). Stand cameras were improved and refined
versions of the old wet-plate view cameras. Hand cameras represented a wide variety of
new camera designs. They yielded a clear picture without the use of a tripod. Inspired
by the dry plate, lens refinements as well as shutter and aperture control mechanisms of
many kinds were introduced concurrently with the new and different cameras.

Stand cameras were view-type, similar to the wet-plate camera but lacking the
chemical stains earmarking a camera of the wet-plate era. Countless models for the
amateur and professional flooded the market. Early dry-plate camera lenses were made
of brass with no shutter mechanism but generally had some form of aperture control.

Later models contained shutters. Added refinements included a swing back and rising front to correct linear distortion.

Beautifully crafted, often made from the best Honduran mahogany and covered with Moroccan leather, folding dry plate cameras flooded the photographic market around the turn of the century. Their interior carried a hand-varnished finish with brass, nickel and ivory fittings. A red leather bellows, characteristic of cameras built before World War I, pulled out on a track seated in the dropping front. Ground glass focusing through a door in the rear of the camera was possible or camera-to-subject distances could be estimated by a distance gauge. Leaf shutters with pneumatic releases, iris diaphragms and rapid rectilinear achromatic lenses are commonly found in folding dry plate cameras from 1895 to 1920. Sizes ranged from small cameras, easily perched on the handle bars of a touring bike, to large semi-portable models that could double as studio cameras. A box camera became a familiar addition to the average household.

IMAGERY

Edward S. Curtis, American (1868-1952)
Prayer to the Stars, ca. 1900
Orotone, 16½" x 13½"

Frank Chadwick(?)
Self-Portrait, 1898
Dry plate glass negative, 7" x 5"
The photographer stands with his view camera set and his hand ready to squeeze the shutter bulb at just the right moment.

Ambulance, ca. 1905
Gelatin-silver print, 19½" x 15"

APPARATUS

The Rochester Optical Company, Rochester, New York
The Rochester Universal, ca. 1890
Wood and brass, 9½" x 9¼" x 11"
All wooden 5" x 7" view camera with brass trim and a Prosch Athlete Shutter (ca. 1886) with adjustable aperture size and shutter speed. A very portable stand camera.

Century Camera Company, Rochester, New York
The Century, ca. 1902
Leather, metal and brass, 6" x 6" x 7¾"
This small-format folding dry-plate camera has an attractive combination of finished wood and brass trim.

Reflex Camera Company, Newark, New Jersey and Yonkers, New York
The Patent Reflex Hand Camera, ca. 1902
Leather and wood, 9¼" x 10" x 14"
An early example of a 5" x 7" single-lens-reflex camera featuring internal focusing mechanism, focal plane shutter and focusing hood.

Ambulance, ca. 1905. The horse-drawn ambulance marked "M. V. M." is surrounded by uniformed soldiers, possibly from the Virginia Militia.

Simon Wing, Charlestown, Massachusetts
The New Gem, ca. 1901
Wood, 9¾″ x 12″ x 8½″
This unique camera has a sliding front lens panel and can take up to 15 exposures on a single 5″ x 7″ glass plate.
Double Dry-Plate Negative, ca. 1900
Glass, 6½″ x 8½″

Rochester Optical Company
The Premier, ca. 1901
Leather and wood, 9″ x 7½″ x 15½″
For 5″ x 7″ plates, this detective box camera was one of the largest box cameras made, equipped with internal focusing bellows and ground glass viewing. The shutter mechanism could be triggered without exposing the lens, making it useful for candid photography. It contained a storage compartment for extra plates.

Stanley Dryplate, Newton, Massachusetts
The Stanley Dryplate, ca. 1885
Twelve glass plates in a paper box, 5″ x 7″

Rochester Optical Company
The 4″ x 5″ Rochester View Camera and Darkroom Outfit, ca. 1895
Wood and brass, 7″ x 6⅝″ x 11″

Rochester Optical Company
Long Focus Premo Camera, ca. 1902
Leather, wood and brass, 7½″ x 8¾″ x 19½″
A unique folding-plate camera with a double extension bellows.

Eastman Kodak Company, Rochester, New York
Bullet Tripod, Model A, ca. 1880-1900
Wood, 44″ x 4″

Twenty-two Glass Plate Negatives in Box, ca. 1900
Box 9″ x 8″ x 6″, plates 8″ x 5″
This wooden box was specially designed to hold glass plates.

COLLATERAL MATERIAL
Spy (dates unknown)
East Birmingham, from *Vanity Fair,* February 20, 1902
Vincent Brocks Day and Son Ltd., lithographers
Lithograph, 12½″ x 7½″

Graflex and Graphic Cameras, 1907
Folmer and Schwing Company, Rochester, New York

J. M. Eder (dates unknown)
Modern Dry Plates or Emulsion Photography, 1881
E. and H. T. Anthony and Company

Towler (dates unknown)
Silver Sunbeam, 1878
E. and H. T. Anthony and Company
A comprehensive book on the art and science of photography.

McAllister (dates unknown)
Photographic Goods, ca. 1900
Paper, 15½″ x 18½″
A hand-painted advertisement.

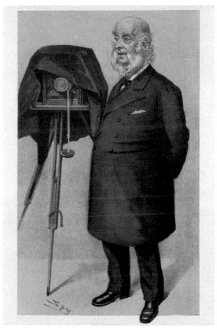

East Birmingham, from *Vanity Fair,* February 20, 1902. A formally dressed, rather stodgy photographer stands beside his camera.

SCIENTIFIC AMERICAN

[Entered at the Post Office of New York, N. Y., as Second Class Matter. Copyrighted, 1888, by Munn & Co.]

A WEEKLY JOURNAL OF PRACTICAL INFORMATION, ART, SCIENCE, MECHANICS, CHEMISTRY, AND MANUFACTURES.

Vol. LIX.—No. 11.]
Established 1845.

NEW YORK, SEPTEMBER 15, 1888.

[$3.00 A YEAR.
WEEKLY.

INSTANTANEOUS PHOTOGRAPHY.

The perfection in the manufacture of gelatino-bromide sensitive compounds is now so complete that photographs are readily made instantaneously with far less trouble than was required in the days of the daguerreotype or of the more recent wet plate process, and this has led, as one would naturally expect, to the invention of special devices for more effectively utilizing the advantages obtained in the use of highly sensitive compounds.

One of the latest ideas based upon the dry process is the production of an extremely simple apparatus, so arranged that it cannot get out of order and adapted for use by the veriest "greenhorn," if we may so speak, or by one who knows nothing at all about photography. All that is required is to point the instrument at the object, press a button gently with finger, and the picture is made.

Another idea is that when a hundred exposures have been made, all the individual has to do is to send the apparatus to the manufacturers, who do all the work of finishing up the pictures. Thus no manipulation whatever is required by the purchaser, save the making of the exposures; the balance is done by persons especially skilled in the art, resulting, as might be expected, in the production of very uniform and satisfactory work. We believe this system has never been before placed on such an extensive commercial scale as is now commenced, and it promises to make the practice of photography well nigh universal.

The absence of removable bulky plate holders, of the drawing out of slides, of any danger from light streaks, will strike those acquainted with the old style of apparatus as being especially desirable, while the fact that one has a large roll of sensitive material to draw from in making the pictures inspires confidence and freedom, since the exposures may be made rapidly, without previous preparation and apparently without limit.

The novel apparatus shown in our engravings is designed to hold enough sensitive paper to produce one hundred pictures about 2⅝ inches in diameter, yet so compact that it measures but 6½ inches long, 3¼ inches wide, and 3⅞ inches high, and weighs less than two pounds. The large engraving represents the actual size of the camera.

The "Kodak," for such is the name given to it by the manufacturers, is essentially a portable camera, intended mainly for making instantaneous exposures,

but may be used for time work also when a secure place can be found to rest it upon. Its simplicity and lightness are its chief features. It consists of an outer rectangular case, neatly covered with black leather, having the rear end closed with a sliding box (see Fig. 2) holding the sensitive paper on a spool, from which,

in unwinding, it passes over an index roll, having an indicator mark in the direction of its diameter on the upper end of its axis, and also metal points on its circumference for puncturing the division line between the pictures. From the supply spool the paper passes over a small measuring roll, thence behind the metal mask having a circular opening, and in front of the

exposing platform, and is finally wound up on the spool to which the key is attached.

As the light can only impinge on the paper within the circular opening, a circular negative is obtained. When the box of sensitive material is slid home into the rear of the camera case, it is prevented from slipping out by the shank of the winding key, passing through the opening in the case, and screwing into the end or axis of the winding spool. It will be observed that all the parts of the supply box are very simple, easily operated, and readily taken apart.

In the front portion of the camera is the shutter and lens, both very unique in their construction. (See Fig. 1, in which the front end protecting the shutter is removed and is shown just below the box. When in place, it clamps the shutter mechanism and is simply fastened by two screws.)

The shutter is cylindrical, having two apertures diametrically opposite each other, and rotates around the two ends of the lens continuously in one direction. In the engraving (Fig. 1) the rectangular aperture of the shutter with the bright disk of the lens in the center is plainly seen. The shutter is propelled by a coiled flat spiral spring located in one end of it, which is wound up by an adjacent ratchet disk wheel, this being in turn operated through miniature pawls by a winding barrel. The latter is rotated by pulling up on the cord which is seen passing through the outer case of the camera in Fig. 1 and in the large engraving. A spring in the winding barrel rotates it in the opposite direction from the pull of the cord, and winds the latter up when released. Two or three short successive pulls on the cord are necessary to wind up the shutter spring to its full tension.

A very ingenious, simple, and positive escapement device is provided in connection with the release button, or pin, for setting off and holding the shutter. The latter will revolve continuously in one direction, stopping at each pressure of the release pin, for at least four or five times, before the shutter spring is completely unwound. The shutter, as will be seen, is very compact, and yet so complete that it cannot get out of order.

The manufacturers state that the lens is of the rapid rectilinear type. It is mounted in a thin metal tube, having a fine screw thread on its exterior. This is held rigidly in the axis of the shutter, and may be

(Continued on page 164.)

Fig. 1.—THE KODAK CAMERA SHUTTER.

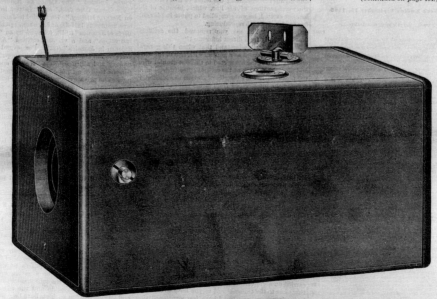

THE KODAK CAMERA—ACTUAL SIZE.—MADE BY THE EASTMAN DRY PLATE AND FILM CO., ROCHESTER, N. Y.

"The Original Kodak," September 15, 1888. The first formal announcement of the original Kodak marked the advent of "instantaneous photography."

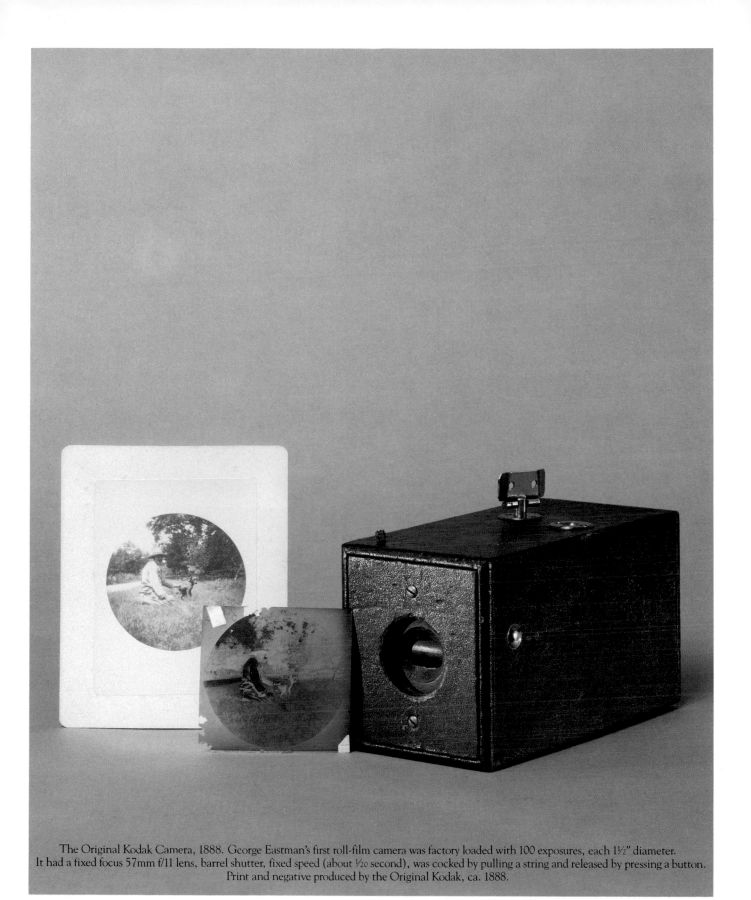

The Original Kodak Camera, 1888. George Eastman's first roll-film camera was factory loaded with 100 exposures, each 1½" diameter.
It had a fixed focus 57mm f/11 lens, barrel shutter, fixed speed (about ⅟₂₀ second), was cocked by pulling a string and released by pressing a button.
Print and negative produced by the Original Kodak, ca. 1888.

THE KODAK AND AMATEUR PHOTOGRAPHY

ROLL FILM AND THE KODAK

The introduction of a practical roll film in 1888 emancipated amateur photographers. In 1854 William Henry Fox Talbot had attempted unsuccessfully to adapt sensitized paper to a pair of wooden rollers. It was George Eastman, with a booming dry plate company already to his credit, who brought photography within the technical grasp of everyone. In 1885, Eastman attached a gelatin emulsion to a roll of supportive paper which, after exposure and development, could be stripped off and mounted on glass for printing. Then, in 1888, he offered the world the original Kodak camera. This first Kodak cost $25 (one month's wages for the average factory worker) and came loaded with enough roll film for 100 pictures. At the end of the roll, the still-loaded camera was returned to Eastman where, for $15, the film was developed, the camera reloaded and returned along with 100 mounted prints. The circular photographs were mounted on a square cardboard backing. A year later, the first transparent roll film made of nitrocellulose, a derivative of collodion, was available. No longer was the clumsy paper backing required to support the light-sensitive gelatin. The credit for this invention originally went to Eastman, but the courts ruled differently, awarding $50 million to the heirs of a New Jersey minister named Hannibal Goodwin, who had filed a patent application for flexible roll film prior to Kodak's application. By 1910, flammable nitrocellulose was replaced by noncombustible cellulose acetate, which is still in use today.

"Substitute for Glass in Photography," *Anthony's Photographic Bulletin,* volume 17, no. 3, 1886
E. and H. T. Anthony Company
Eastman Dry Plate and Film Company's introduction of the Eastman Walker roller holder, designed by George Eastman and William Walker, marked the birth of roll film photography. It was followed by the introduction of the Kodak two years later.

EARLY ROLL FILM CAMERAS

Roll film delivered the ultimate in picture taking simplicity. George Eastman's original Kodak of 1888 enabled those with absolutely no mechanical aptitude to take pictures, giving rise to a population of amateur buttoners, who fluttered about like butterflies in the sunshine. In 1891, Eastman marketed its first daylight-loading camera and roll film, which enabled photographers to load their own cameras rather than sending them back to the Kodak factory in Rochester. Concurrently, Eastman produced developing outfits for home processing by the amateur. Other manufacturers soon followed with camera models using Eastman's roll film.

The 1890s saw a distinguished cast of beautifully crafted wooden box cameras equipped with a variety of shutters, aperture control devices and finished exteriors. The mid-1890s also saw the emergence of the popular folding glass-plate camera, which could use roll film with the addition of a rollholder in the rear. The first Brownie camera was marketed in 1900, selling for $1; film cost 15 cents a roll. George Eastman was a champion of the amateur, and the Brownie line of Kodak cameras put photography within most people's grasp. In time, Eastman Kodak absorbed many of the smaller companies and became the dominant photographic manufacturer in the United States.

KODAKERY

"You press the button, we do the rest" was Kodak's slogan in the early 1890s. Kodakery became an excuse to travel and see the world. Amateur photography's popularity spread quickly through America and Europe. By 1891, 150 camera clubs were established in this country. Hotels routinely enticed tourists by providing darkrooms for photo-processing on the premises. Photography journals resembling the *Farmer's Almanac* abounded in weather predictions to assist the trigger-happy snapshooter who wanted to plan ahead.

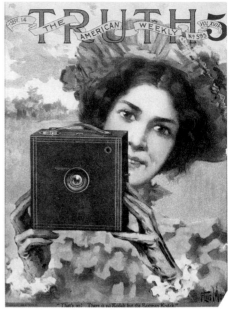

A turn-of-the-century five cent magazine. The cover is a colored lithograph by Mora of a young female amateur photographer capturing the "truth" in 1898 with her quick and easy box camera by Kodak. The caption reads "That's so! There is no Kodak but the Eastman Kodak."

"The Original Kodak," September 15, 1888
The Scientific American, volume LIX, no. 11

Eastman Dry Plate and Film Company
The Original Kodak Camera, 1888
Wood and leather, 4″ x 3¼″ x 6¾″

Eastman Dry Plate and Film Company
The Kodak Camera, 1888
Advertisement, ink on paper, 9¾″ x 6¾″
The introduction of the Kodak camera marked the dawn of photography made simple.
Making photographs was now within the technical grasp of everyone.

Three Prints and One Negative produced by the Original Kodak, ca. 1888
Gelatin-silver prints, each 2½″ diameter

Eastman Kodak Company
The No. 1 Brownie, ca. 1900
Wood, leather and metal, 3¼″ x 3¼″ x 5″
Conceived by Palmer Cox around 1878, Brownies were dandy little elf-like creatures
who captured the hearts of children in the 1880s and 1890s much like Mickey Mouse.
Friendly, hardworking and appealingly impish, a Brownie seemed like an ideal char-
acter after whom to name a camera. The production of paper and cardboard cameras
disturbed people who were accustomed to the quality wood, brass and leather construc-
tion of prior Kodaks. However, the Brownie was a stroke of marketing genius, as this
new line of inexpensive cameras flourished for more than 60 years.

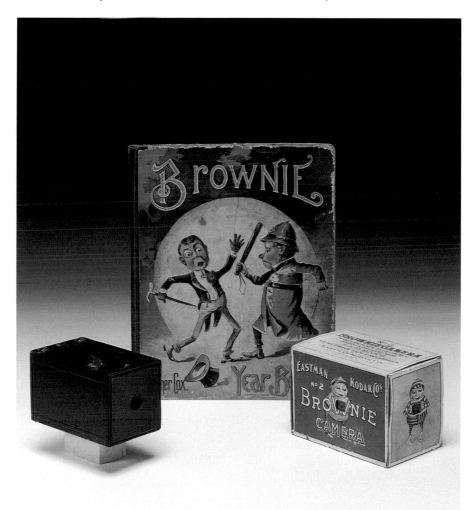

*The No. 1 Brownie, ca. 1900; Brownie Year
Book, 1895; Brownie Cardboard Box, ca. 1920.*

Eastman Kodak Company
Brownie Cameras, ca. 1900
Munsey's Magazine, Frank A. Munsey and Company
Advertisement, ink on paper, 9¾" x 6¾"
Palmer Cox, b. Canada (1840-1924)
Brownie Year Book, 1895
McLoughlin Brothers Publishers

Eastman Kodak Company
Brownie Cardboard Box, ca. 1920
Paper box, 4¼" x 3⅝" x 6"
An original carton for the No. 2 Brownie.

Eastman Kodak Company
The Pocket Kodak, 1897
Wood, leather and metal, 3" x 2⅜" x 3⅞"
Of the first small cameras, Eastman wrote "We are making as a starter five batches of
5,000 each. . . . It is a daisy, and ought to be in every home." The cost was a mere $5.

Three Prints taken by the Pocket Kodak, ca. 1897
Gelatin-silver prints, each 1½" x 2"

Eastman Kodak Company
These 1931 Kodaks . . .
Ladies Home Journal, December 1930
Advertisement, ink on paper, 13⅞" x 10¾"
There was no shortage of color among the many Kodak cameras manufactured from
1900 to the present day.

Eastman Kodak Company
Red, 120 Brownie, ca. 1930
Wood and leather, 4½" x 3" x 5½"

Eastman Kodak Company
Turquoise, No. 2 Beau Brownie, ca. 1930
Metal and leather, 5" x 5" x 3¼"

Eastman Kodak Company
Brown, 1A Pocket Kodak, ca. 1930
Metal, 3½" x 8" x 1½"

Eastman Kodak Company
Red, Rainbow Hawkeye, 2A Folding, ca. 1930
Metal, 2¼" x 4¾" x 1"

Eastman Kodak Company
Green, Rainbow Hawkeye, Vest Pocket, ca. 1930
Metal, 2¼" x 4¾" x 1"

Eastman Kodak Company
Blue, Rainbow Hawkeye, Folding No.2, ca. 1930
Metal, 3" x 6½" x 1½"

Eastman Kodak Company
The Postcard Kodak, ca. 1914-1934
Metal and leather, 4¾" x 9¾" x 2"
Retaining its postcard-size format, this popular Kodak model went through numerous
changes over its 20 years of production.

Eastman Kodak Company
Make Children Happy with a Kodak, ca. 1914-1934
Advertisement, ink on paper, 14¾" x 9½"

Hutchinson and Svensden (dates unknown)
Miss Camille Clifford, 1905
Gelatin-silver print postcard, 5½" x 3½"

Tall Ship Scene, ca. 1915
Gelatin-silver print postcard, 3⅜" x 5⅜"

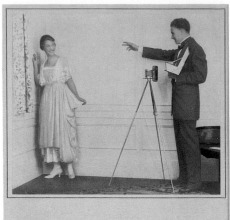

Kodak knows no dark days

A Kodak advertisement praising the merits of
the magnesium flash system. Yes! the Kodak
of your choice could be used in any low-light
situation.

Street Scene, ca. 1915
Gelatin-silver print postcard, 3½" x 5½"
Soldier with Camera, ca. 1915
Gelatin-silver print, 5¼" x 3⅛"

Eastman Kodak Company
The Satchel Kodak, or No. 4 Folding Kodak, 1890
Wood and leather, 7¼" x 8" x 6½"
Advanced amateurs found the original Kodak camera too simple; they wanted a camera
with professional controls. George Eastman complied with the folding Kodak cameras:
the swings and tilts of a view camera combined with the convenience of a roll-film
camera plus an ever-ready case. The No. 4 refers to the 4" x 5" picture format.

Eastman Kodak Company
The C-Ordinary Kodak, ca. 1894
Metal and wood, 6½" x 5" x 11¼"
This finished wood early string-pull shutter Kodak took 4" x 5" pictures with a roll film
capacity for 24 exposures. The roll-film back could be removed and replaced with a
special attachment for glass plates. The price was $15.

Eastman Kodak Company
The Anniversary Kodak Camera, 1930
Paper and leatherette, 4½" x 3" x 5½"
If you were 12 years old in 1930, George Eastman had a giveaway for you. It was the
Anniversary Kodak, which commemorated the company's 50th anniversary; 500,000
of these cameras were distributed.

These 1931 Kodaks . . ., Ladies Home Journal,
December, 1930; Brown, 1A Pocket Kodak;
Red, Rainbow Hawkeye, 2A Folding; Blue, Rain-
bow Hawkeye, Folding No.2; Green, Rainbow
Hawkeye, Vest Pocket; Red, 120 Brownie; Tur-
quoise, No. 2 Beau Brownie.

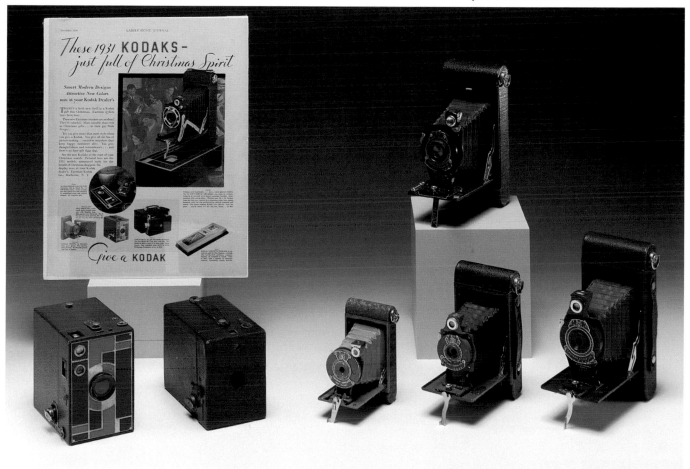

Eastman Kodak Company
Have you a child born in 1918..?
The Saturday Evening Post, May 3, 1930
Advertisement, ink on paper, 14″ x 10⅞″
Promotional offering for the Anniversary Kodak.

COLLATERAL MATERIAL
Eastman Kodak Company
Kodak, 1907, 1928 and 1930; *The Kodak on the Farm,* 1908; and *Kodakery,* 1928
Catalogues, ink on paper
The Kodak Company excelled in the design of its promotional material.

Eastman Kodak Company
The Kodak Darkroom, ca. 1920
Kodak Film Tank, 6″ x 5¾″ x 9¾″
Eastman Timer, 5″ x 2½″ x 5½″
Kodak Scale, 9″ x 4″ x 4″
Kodak Collapsible Darkroom Lantern, 6″ x 6½″
Miscellaneous Chemical Containers

Eastman Kodak Company
Development is Easy with a Kodak Tank,
ca. 1920
Advertisement, ink on paper, 13½″ x 10½″

Eastman Kodak Company
Kodak Knows No Dark Days, ca. 1915
Advertisement, ink on paper, 13″ x 9″

George Richards and Son (dates unknown)
We Sell Kodaks, ca. 1910
Wood, 15¼″ x 66½″ x ¾″
Mr. Richards was a jeweler on Main Street
in Winsted, Connecticut, who sold
Kodaks. The store still stands.

J. E. Green (dates unknown)
Camerawoman and Stream, ca. 1920
Gelatin-silver print, 10⅝″ x 13⅝″
A rustic scene showing a woman taking a
photograph with a Kodak folding camera.

Francis Luis Mora, American, b. Uruguay
(1874-1940)
Truth, September 14, 1898,
volume XVII, no. 595
Magazine cover, ink on paper, 10¾ x 7¾″

Alexander Black (dates unknown)
Captain Kodak – A Camera Story, 1899
Lathrop Publishing, Boston
The adventures of a young boy
and his camera.

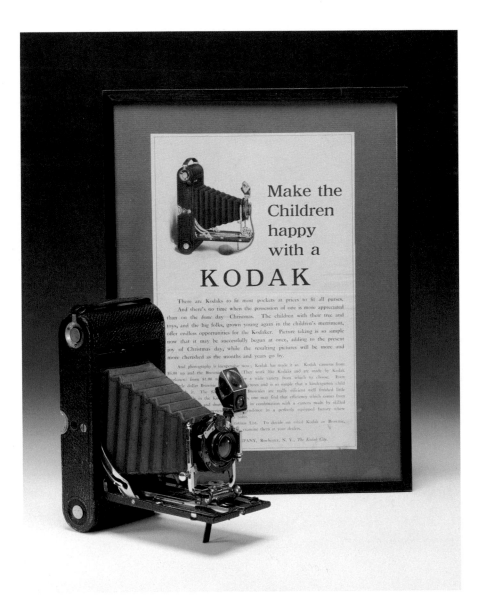

The Postcard Kodak, ca. 1914-1934.

CANDID/DETECTIVE PHOTOGRAPHY

Stirn and Lyon, 20 Park Place, New York (dates unknown)
C. P. Stirn's Photographishe Camera, ca. 1886
Nickel plated, 6½" x 2½"

Stirn and Lyon, *C. P. Stirn's Patent Concealed Vest Camera*
Advertisement, ink on paper, 4¼" x 3"

Detective Tripod, ca. 1880
Wood and metal, 37½" x 1½"

Minox, Germany
Minox Sub-Miniature Camera with Flash and Film, ca. 1940
Metal, 4½" x 1" x ¾"

Since its introduction in 1938, this mechanical mini-masterpiece of precision (8mm x 11mm film format) has been the most widely used spy camera for espionage and clandestine photography. After 50 years, this landmark camera is manufactured no longer.

William R. Whittaker Company, Ltd., Los Angeles, California
Micro 16, ca. 1950s, metal, 1" x 2" x 2⅞"
This 16mm subminiature fits neatly inside a pocket for casual use or inside a package of cigarettes for detective work.

C. P. Stirn's Patent Concealed Vest Camera, ca. 1886. Hanging from a neck strap, this nickel-plated detective camera could be concealed under a vest with the lens protruding through a buttonhole. The shutter was tripped by a string running down into the pocket. A circular plate six or seven inches in diameter permitted four to six small photos to be taken. By 1891, 18,000 had been sold. The price was $15. *Detective Tripod*, ca. 1880. This tripod was designed to look like a cane to keep the candid photographer's intentions from being noticed. *The Expo*, ca. 1910. A camera disguised as a railroad pocket watch with the lens underneath the winding knob.

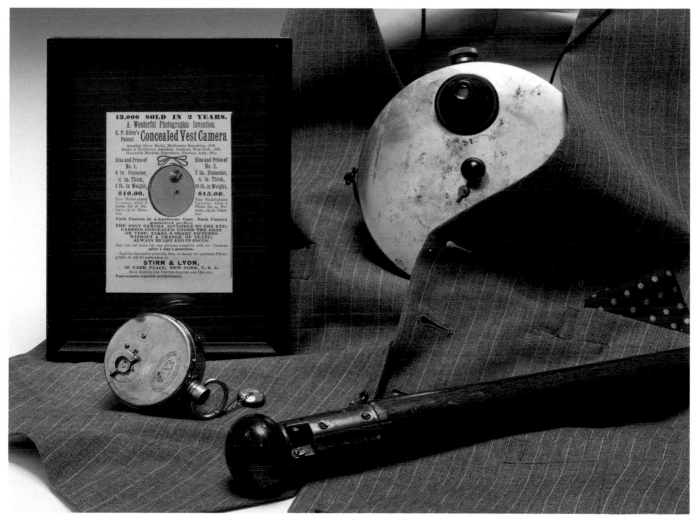

ALFRED STIEGLITZ

"I was born in Hoboken. I am an American. Photography is my passion. The search for Truth my obsession." Alfred Stieglitz (American, 1864-1946) lived his life fighting for photography as art. Through his galleries 291 and An American Place, *Camera Work* journal and the Photo-Secession, he sought a place for the art of photography among the arts of old. He purchased his first camera in 1883 and printed many of his images in the photogravure method.

 Photogravures were photo-mechanical prints introduced in Vienna in 1879. The copper photogravure plate yielded approximately 1,000 prints.

Winter – Fifth Avenue, 1893
Photogravure, 6¾″ x 5¾″

Early Morn, ca. 1895
Photogravure, 5¾″ x 8″
A bucolic European country scene.

A Happy New Year, 1894
Photogravure, 7¾″ x 5¾″

Alfred Stieglitz, *Winter – Fifth Avenue,* 1893. Taken on George Washington's birthday with a hand camera, Stieglitz spent six hours waiting for the right moment to expose his plate. He realized the importance of this photograph and declared it as marking the beginning of a new era in photography. This photogravure appeared in the *Photographic Times Magazine* in 1897.

The Graflex, ca. 1902. The single-lens reflex, allowing the photographer to see the exact image up to the instant of exposure, was well known when William F. Folmer (dates unknown) designed a greatly improved model, the Graflex, which became a classic. He improved the focal-plane shutter and linked the mechanism for moving the mirror to the shutter release so that pressing one button was all that was required to make an exposure. The fast ⅟₁₀₀₀-second shutter speed made it ideal for sports photography. It was also favored by pictorial photographers. Alfred Stieglitz wrote Folmer in 1905: "It is against my principles to give testimonials except on rare occasions – and this is to be one of those occasions, for I believe you have fully earned that distinction. Ever since the Graflex has been on the market I have used it for many purposes. At present I own a 5 x 7, 4 x 5, and 3¼ x 4¼. . . . It is beyond my understanding how any serious photographer can get along without at least one."

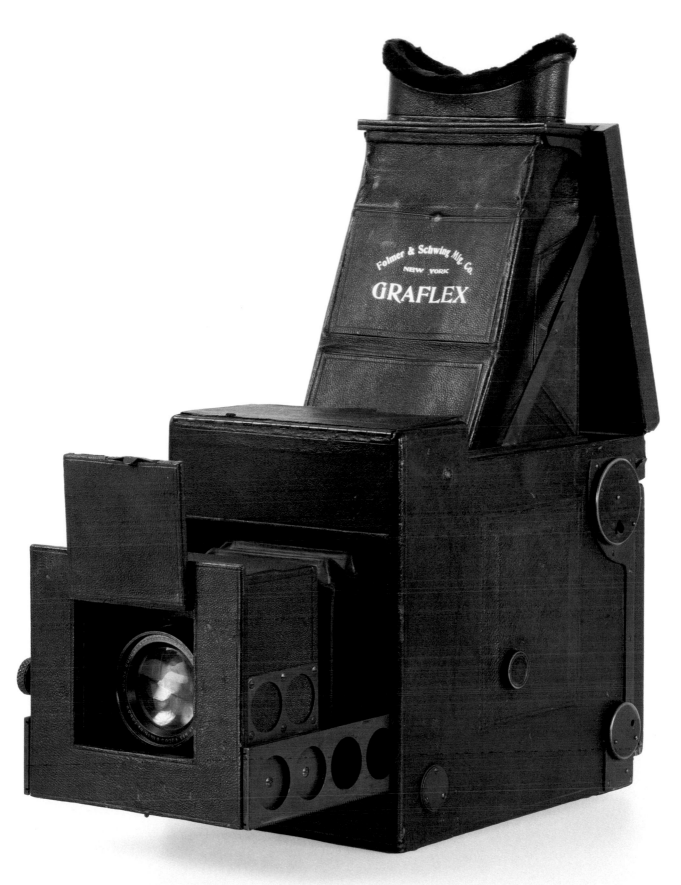

THE PRESS PHOTOGRAPHER

Epear Franklin Wittihack (dates unknown)
At Work, Saturday Evening Post, November 7, 1936
Magazine cover, ink on paper, 12½" x 9¼"
Photographers photographing Franklin Delano Roosevelt casting his presidential ballot.

C. A. Peterson (dates unknown)
Cover, *American Girl,* May 1946, volume XXIX, no. V
Ink on paper, 11½" x 8½"
A photographer beside her trusty Speed Graphic.

The Baltimore Fire, Extinguishing Flames, 1904
Gelatin-silver print, 5½" x 7⅜"

The Baltimore Fire, Aftermath on the Wharf, 1904
Gelatin-silver print, 5⅞" x 7⅛"

Folmer Graflex Corporation
The Speed Graphic, ca. 1940
Metal and leather, 7¾" x 8" x 10"

Folmer and Schwing Manufacturing Company, New York, New York
The Graflex, ca. 1902
Wood, leather, and metal, 17" x 7" x 10"

Magnesium Flash Unit, 1915
Wood and tin, 12" x 12" x 1¾"
An example of an early flash tray for magnesium powder.

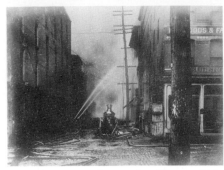

The Baltimore Fire, Extinguishing Flames, 1904. The Great Fire of 1904 devastated the downtown area of Baltimore, making it possible to rebuild a better city.

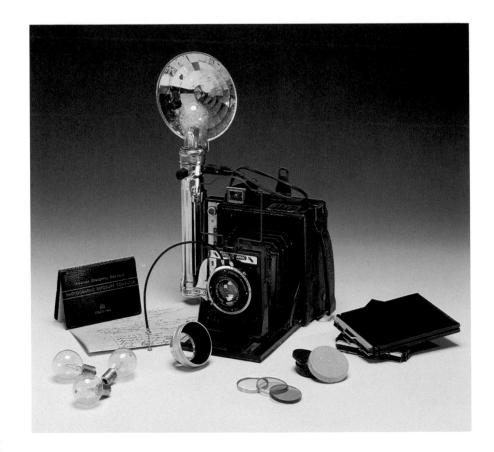

The Speed Graphic, ca. 1940. The standard work horse of the press photographer, the Speed Graphic remained almost unchanged since the first model was introduced in 1912.

THE MODERN ERA

The grand flowering of the modern era of photography began with the popularization of the 35mm film format. There is a fascinating story concerning George Eastman and Thomas Edison (1847-1931). While walking in a garden in 1889, they discussed Edison's need for motion picture film. Edison gestured and made a small space between his thumb and forefinger, "George, make it that wide." Such is not the real story as we read from *A New Look at the Old 35,* by Thurman F. Naylor.

Working for Edison, young engineer W. K. L. Dickson was charged with the development of a motion picture camera, the Edison Kinetoscope, and later a motion picture projector. Dickson needed long strips of film, wide enough for a 1″ image, perforated for indexing and strong enough to resist tearing. George Eastman was a visionary, and as such, was excited about the staggering amount of film which would be used when motion pictures became practical. Both men had incentive to make it happen.

Dickson and Eastman agreed on film 1⅜″ wide. Why 1⅜ inches? The original Kodak, announced a few months earlier in 1888, used 2¾″ roll film. The equipment was being built in Rochester to produce 2¾″ film in great quantities. 2¾″ film happens to be 70mm and when sliced in half is 1⅜″ or 35mm. Thus 35mm film was born, and the motion picture industry had a beginning. A still camera using the same film followed. It wasn't long before an international agreement was reached to standardize the width and sprocketing of 35mm film. According to Naylor, it seems likely that economics coupled with initiative, and the hope of a technically successful and profitable venture, spurred the development of cameras using 35mm film.

APPARATUS

E. Leitz, Wetzlar, Germany
The Leica 1 (Model A, Serial 3492), ca. 1925
Metal, 2½″ x 5″ x 2½″
The Leica caused a revolution in photography. Of the many cameras designed especially to take still pictures on standard 35mm motion picture film, the Leica, invented in 1912 by Oskar Barnack of the optical house of E. Leitz, Wetzlar, Germany, was the first to gain widespread acceptance. Production models were put on the market in 1925. The body shape, lens (50mm, f/3.5 Leitz Anastigmat), focal plane shutter, double-frame (24 x 36) format and metal film cassette, suggest the design of 35mm cameras to follow.

Zeiss Ikon, Dresden, Germany
Contax 1, ca. 1934
Metal, 6″ x 3″ x 3″
The success of 35mm photography is due to the introduction of fine-grain emulsions and precision in camera manufacture. The Contax of Zeiss brought precision to new heights in the 35mm format. It featured interchangeable bayonet lens mounts, an all-metal shutter and the introduction of a rangefinder coupled with the lens for precise focus. The Contax series was manufactured until 1961. Zeiss was the premier German camera manufacturer for many years.

Rolleiflex, ca. 1935. First introduced in 1929, the Rolleiflex was the archetype of the 6 x 6 (2½″ square) twin-lens reflex popular to this day. Countless copies of the same design have seen production from all over the world. Eaton Lothrop's *Century of Cameras* notes: "Although the twin-lens reflex had been introduced approximately a half-century earlier and had enjoyed extreme popularity around the turn of the century, it was no longer in general use at the beginning of World War I. The Rolleiflex took advantage of all-metal construction (the earlier twin-lens reflex had been made of wood) to produce a small, compact and sturdy instrument that compromised between the negative size of the plate camera in general use and the novel 35mm film format of the Leica." *Weston Light Meter,* ca. 1930s. A photoelectric selenium cell was first used in a Weston meter in 1932.

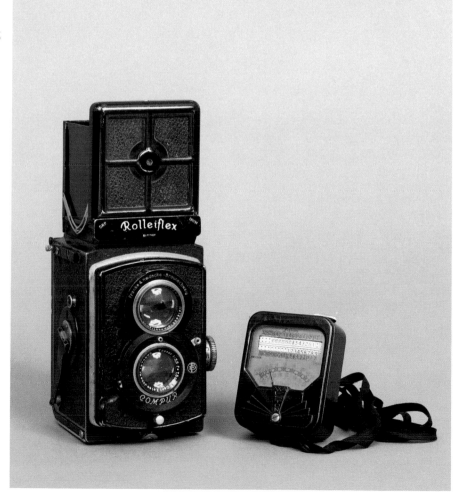

Thagee, Dresden, Germany
Exacta, ca. 1933
Metal and leather, 4″ x 6″ x 4″
The Exacta camera was introduced in 1933. Its landmark design anticipated all modern single lens reflex cameras with its mirror cocking design and general layout. This model is the Exacta VX with a bayonet mount for interchangeable lenses.

Agfa Ansco Company, Binghamton, New York
Memo, ca. 1930
Wood and metal, 5″ x 2¼″ x 2½″
While several years in development, The Ansco Memo was formally introduced in January 1927. Priced at $20, with a suede case, the Memo cost far less than other 35mm cameras and achieved widespread popularity in the United States. Memo advertising stressed economy in camera price and low film cost. "Fifty pictures with one fifty cent film."

Graflex, Rochester, New York
National Graflex, ca. 1934
Metal and leather, 7″ x 5¾″ x 4¼″
An ingenious single lens reflex for 2½″ x 2½″ images on 120 roll film.

Franke and Heidecke, Germany
Rolleiflex, ca. 1935
Metal and leather, 8″ x 3½″ x 3½″

Agfa Ansco Company
Agfa View Camera and Contact Printer, ca. 1930
Wood, leather and brass, 11¾″ x 9½″ x 16½″
Wooden view camera with brass trim, rising front, tilting back, folding bed and lens shutter. A sturdy, versatile 5″ x 7″ view camera similar to the one used by Ansel Adams early in his career.

Watkins Meter Company, Hereford, England
Bee Exposure Meter, ca. 1890
Metal and glass, 2½″ x 1¾″ x ⅜″
These meters used the time it took for a light-sensitive paper to change color to calculate the exposure. The cap swung from a chain to count the seconds!

Watkins Meter Company
Standard Exposure Meter, ca. 1890
Brass, 2″ x 1⅜″

Weston Corporation, Newark, New Jersey
Weston Light Meter, ca. 1930s
Bakelite, 2¾″ x 2¼″ x 1″

COLLATERAL MATERIAL
Ansel Adams, American (1902-1984)
Time, September 3, 1979
Magazine cover, ink on paper, 11″ x 8¼″
This celebrated photographer produced some of the most famous and exquisite images of the 20th century.
Clark Gable with Auto Graflex Camera, ca. 1935
Gelatin-silver print, 9½″ x 7½″

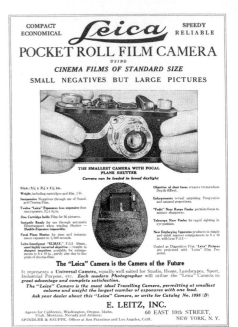

INSTANT PHOTOGRAPHY

Polaroid Corporation, Cambridge, Massachusetts
Model 95, ca. 1948
Metal and leather, 10½" x 5¼" x 7½"

Polaroid Corporation
Avanti Quad Camera, ca. 1960
Metal, 6½" x 9¼" x 6½"
A specialty camera with "4 tubes" much like the camera for multiple images a century earlier. This one with a Polaroid back.

Polaroid Corporation
SX-70, 1972
Metal and leather, 5½" x 4¼" x 7"

Magic Camera, LIFE, October 27, 1972
Magazine cover, ink on paper, 13" x 10½"

Model 95, ca. 1948. The first Polaroid Land Camera caused pandemonium when it went on sale in Boston on November 26, 1948. *Magic Camera, LIFE*, October 27, 1972. *SX-70*, 1972. "Photography will never be the same after today," Edwin Land (American, 1909-). The innovations of the SX-70 were truly revolutionary. In his noted biography of Land, Peter C. Wensberg wrote of the SX-70's formal introduction to the public: "The audience, a few less than four thousand, heard and believed. I believed. I had staged the show and still I believed. Even now, from the vantage of fifteen years, I am sure that with the SX-70, Land changed the commonly accepted mechanics of photography more than any man since Fox Talbot."

NOTES

Unless indicated, the artist or maker is unknown.

Dimensions are listed as height, width, depth unless noted otherwise.